THE HAUNTED
NATCHEZ
TRACE

BUD STEED

Haunted
America

Published by Haunted America
A Division of The History Press
Charleston, SC 29403
www.historypress.net

All cover images appear courtesy of the author's collection

First published 2012

Manufactured in the United States

ISBN 978.1.60949.531.2

Library of Congress Cataloging-in-Publication Data

Steed, Bud.
The haunted Natchez Trace / Bud Steed
p. cm.
Includes bibliographical references.
ISBN 978-1-60949-531-2
1. Ghosts--Natchez Trace--Anecdotes. 2. Haunted places--Natchez Trace--Anecdotes. 3.
Parapsychology--Natchez Trace--Anecdotes. 4. Natchez Trace--History, Local--Anecdotes.
5. Natchez Trace--Social life and customs--Anecdotes. I. Title.
BF1472.U6S739 2012
133.10976--dc23
2012006917

CONTENTS

DEDICATION AND ACKNOWLEDGEMENTS

This book is dedicated to my wife, Jennifer Lynn Steed, who has never, over the years that we have spent together, ever lost faith in me, even when I have lost faith in myself. She has always been my constant cheerleader, offering words of encouragement and a hug and a kiss in those moments when I doubted myself and my abilities. She is my rock, and I love her for it.

To my kids, David, Sean, Ciara Jo and Kerra Lynn, I thank you for your understanding and patience when I was too busy writing and researching to throw the baseball or football with you or simply hang out and watch a movie. It's not easy being my kids, but you manage it well, and I love you all more than life itself.

To my oldest daughter, Bobbi Jo, I miss you constantly, and not a day passes that I don't think of you or wonder what your life would have been like. Rest in peace sweetie, we all love and miss you.

To my good friend David Harkins, who is also the founder and director of our paranormal investigation team, The Ozarks Paranormal Society, thanks for always being there with a word of encouragement and helpful advice when I needed it. You've never let me down, brother, and I respect no man more than you.

To my parents, Merlin Sr. and Rose Steed, I thank you for never giving up on me, even though I gave you ample reasons to do so. Your encouragement, love and forgiveness over the years has been much appreciated, and I can

only hope that I end up being half the parent to my children that you two were to me. I love you guys.

Lastly, thanks to Willie Aldridge, who took the time to stop and pick up a young man one evening just south of Raymond. I had busted the chain on my old Harley and was standing there uttering a few unkind words when he stopped in his ancient beat-up Chevy pickup. He took me into Jackson to get a new chain and brought me back to my bike, waiting and visiting while I fixed it. His stories about the Trace, the Land Pirates and the dirty deeds they committed have stayed with me ever since. He was a black man who was born and raised on a sharecropper's farm near Port Gibson and whose daddy had been a slave. When he stopped to help me in 1983, he was ninety-three years old and was active and spry with a sharp mind and easy smile. He insisted on staying with me while I fixed the bike, telling me in his heavily accented southern drawl that "they things in them there woods what don't know they dead. Haunts and such." He then regaled me with ghost stories until I was finished, refused payment for his gas and time and drove away with a wave. I saw Willie twice after that and visited with him for a bit each time. Several years went by before I could get up that way again to see him, only to find that he had passed away, and his old shack had been torn down; the spot where it had stood was planted in cotton. He was a wealth of knowledge and a kind soul. May he rest in peace.

I would like to acknowledge the help that I received while researching and writing this book. Jennifer was a huge help on our road trip down the Natchez Trace, helping take photos, jotting down notes and performing the job of navigator with exceptional ease. She helped make a fast working trip into a fun get away. The sketch of Samuel Mason was drawn by Anne H. Foreman, an accomplished artist who graciously allowed me to include it in this book. My editor, Will McKay, was always quick to answer my questions, clarify an issue for me and assist me in any way that he could. Thanks to Janie from the Southern Lagniappe website for pointing me in the right direction for more information on the Windsor Ruins. Lastly, thanks to Aaron Morris and the Operations Staff at RBX for giving me the time away that I needed to get this project completed.

The History of the Natchez Trace

Taking a drive on the Natchez Trace is like stepping back in time. The gently winding roadway passes through quiet farms, forests and swamps, originating at its southern terminus near Natchez, Mississippi, passing through the entire state of Mississippi and the northwest corner of Alabama to finally end near Nashville, Tennessee. Along the way, one cannot help but notice the lack of billboards, signs and traffic lights, not to mention the absence of commercial traffic. All of this, with the fifty-mile-per-hour speed limit, lends itself well to a peaceful and relaxing drive, easily bringing to mind a simpler, slower time before commercialization and instant gratification took control of nearly every aspect of our lives and landscapes.

But as peaceful and relaxing as it may seem today, it was once one of the most dangerous and bloody roads in existence. Often referred to as "the Devil's Backbone," it harbored thieves and murderers who preyed upon weary and unsuspecting travelers. Highwaymen known as "land pirates" roamed the Trace, plying their violent trade wherever opportunity presented itself, and hundreds of people disappeared along its length, never to be seen or heard from again. Men such as Sam Mason, John Murrel, the Harpe Brothers and countless unnamed brigands terrorized the Trace from the mid-1780s through the 1830s, when, with the advent of steamboats, foot travel along the Trace dwindled to nearly nothing.

With all of the bloodshed and murder along the Trace, it's no wonder that tales of hauntings and ghosts have come to be associated with some of

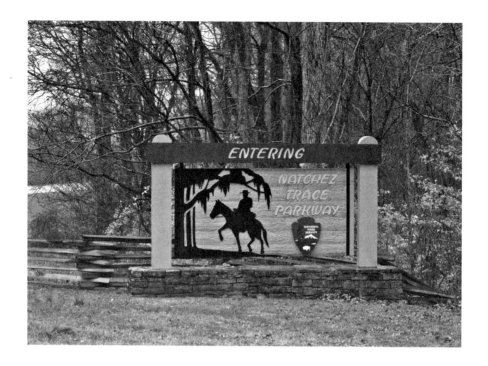

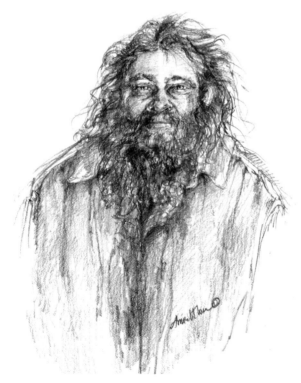

Above: Entrance sign to the Natchez Trace Parkway. *Photo by Jennifer Steed.*

Left: Sketch of land pirate Samuel Mason. *Courtesy of Anne H. Foreman.*

its better-known historical locations. To better understand how stories and legends of ghosts have appeared along the Trace, you need only look at the history of the road.

THE TRACE

Thought to be in excess of eight thousand years old, the Natchez Trace originated as a game trail that followed the higher, dryer ground. Large animals, such as buffalo and deer, trampled down the underbrush on their way north to the salt licks near modern-day Nashville, and later, Native Americans would utilize the pathways while traveling to hunt and trade, further developing it into a wider and better route. Early explorers, who relied on the Chickasaw and Choctaw as guides, would have utilized the Trace as well, and it is speculated that Hernando de Soto, the famous Spanish explorer, used the path as he explored northward searching for gold.

Early travelers continued to use the Indian trails when moving north from Natchez and New Orleans, and what would become the Natchez Trace was the trail most frequented. Even before the purchase of the Louisiana Territory from France in 1803, it was widely recognized that a permanent, more improved roadway was needed, and in 1800, Congress paved the way for a postal route between Nashville and Natchez. A treaty with the Chickasaw Nation in 1801 allowed the United States to build a road through native lands from Tennessee to Natchez, and the formal establishment of the Natchez Trace began. This connected with the Wilderness Road at Nashville and became the accepted route of travel from Nashville southwest to the Louisiana Territory and back northward.

The road from Natchez north to Nashville was most frequented in the late 1700s to early 1800s by "Kaintucks," farmers and loggers who would build flatboats with which to float their goods from Pennsylvania, Ohio and Kentucky down the Ohio River. From there, they would connect with the Mississippi River and then on down to the markets in Natchez and New Orleans. Unable to pole their flatboats back up the Mississippi River due to the extremely fast and hard currents, they would sell the flatboats for lumber or simply abandon them and then walk from Natchez back northward to their homes. It was estimated that in 1810, more than ten thousand Kaintucks had traveled north on the Trace, heading home with the proceeds of the sale of their goods. With that many men frequenting the Trace with good sums of money in their pockets, its little wonder that murder and robbery were the

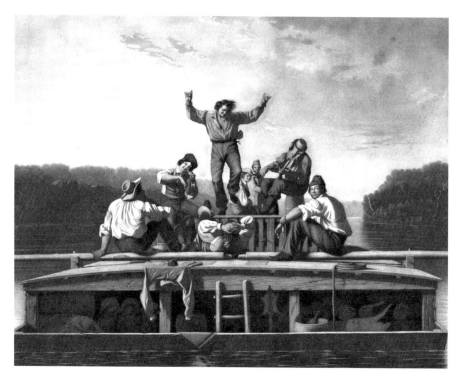

1847 painting titled *The Jolly Flatboat Men*. Originally painted by G.C. Bingham and engraved for printing by Thomas Doney. *Courtesy of the Library of Congress.*

number one danger on the Trace. It was in these times that the names of men such as John Murrel, Joseph Thompson Hare, Sam Mason and the Harpe brothers became synonymous with murder and robbery. Travelers would be killed, their bodies disemboweled and the cavities filled with rocks. The bodies would then be sunk in a convenient creek or river, and the entrails left for the wild animals, and all trace of the foul deeds would be gone forever. No one knows how many travelers met their fates in such a way, but one can only speculate that the number would be quite high simply due to the large numbers of men traveling the Trace.

Travel along the Trace at that time was a long, dangerous hike, taking upward of thirty-five days to walk the nearly five hundred miles. Those lucky enough to have been able to afford horses for the return trip would have been able to narrow the time frame down to around twenty-five days. Men would form groups for the express purpose of traveling back north along the Trace, adhering to the standard of safety in numbers. Shelter

and a meal could be found at "stands," wayside inns, and these stands would have been a welcome sight for travelers, not only for the meager meal and a place to sleep, but also for the added protection that they would have afforded. On average, the stands would be located five to six miles apart, though they were not as closely spaced during the early days of the Trace. Most were operated by Indian families of the Chickasaw and Choctaw Nations through concessions granted by the tribe's leaders, and for those lucky enough to be granted a concession, it would have been a lucrative endeavor. Others, such as Mount Locust, just fifteen miles from Natchez, started as farms and grew to become successful plantations and stands along the Trace. Travelers could find shelter and a meal for only twenty-five cents before continuing their treks northward.

Travel along the Trace was attempted not only by the returning Kaintucks but also by soldiers and volunteers. Andrew Jackson and his volunteers walked the Trace on their return from the Battle of New Orleans during the War of 1812. A frequent traveler along the Trace, Jackson even made mention in his diary about the curious burnt areas of grass at the Witch Dance near Tupelo. Famed explorer Meriwether Lewis met his demise in 1809 at Grinder's Stand along the Trace, and his death has been a subject of controversy ever since. Shot twice, once in the head and once in the side, he lingered for hours before dying, ruled to be a victim of suicide, though some think murder was a more accurate assessment.

Travel continued along the Trace, though by 1825 it had diminished greatly. The advent of steamboats made the return trip much easier and safer for the Kaintucks and other travelers, and fewer and fewer people traveled the Trace. Stand sites were abandoned, and the Trace fell into disuse, frequented only by locals and those who were too poor to pay, or simply refused to pay, the fare required to ride the steamboats. Murder and robbery were still plied along the now less frequently traveled Trace, though some believe that when John Murrel was captured and sent to the Tennessee Penitentiary in 1834, that era of lawlessness was brought mostly to a close.

The years from that point until the start of the Civil War were mostly uneventful, with the Trace being used mainly by plantation workers and travelers on local business. During the war, the area along the Trace saw several battles and skirmishes, as well as organized troop movements. The graves of thirteen unknown Confederate soldiers lie along the Trace near Tupelo as a stark testament to lives lost in a war that saw families torn apart simply by differing ideologies.

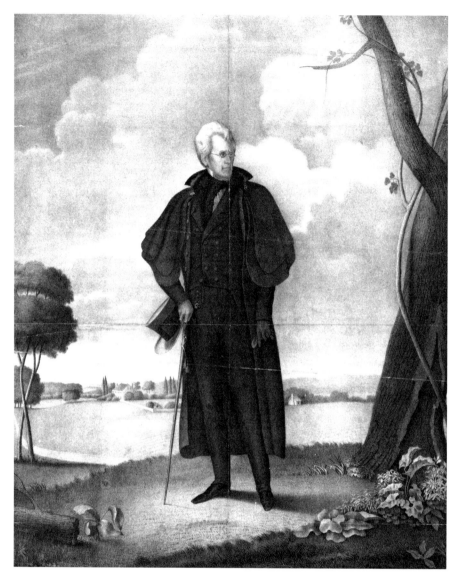

An 1833 painting of Andrew Jackson. *Courtesy of the Library of Congress.*

The frequent bloodshed and violence along the Trace have left behind their imprint in the form of ghosts and haunts. From the Windsor ruins to ghost towns and from abandoned cemeteries to dark cypress swamps, long forgotten except for the spirits who haunt them, strange and eerie stories have been told along the Trace from nearly its inception. Follow along as we start our trip up the Haunted Natchez Trace.

PART 1

MISSISSIPPI

NATCHEZ NORTH
TO JACKSON, MISSISSIPPI

We will start our trip up the haunted Natchez Trace at its southern terminus of Natchez, Mississippi, much the same as the Kaintuck boatmen would have done over two hundred years ago. Many things have changed since that time, and the Trace itself would be totally unrecognizable to the Kaintucks much in the same way that the Trace of their time would be so alien to us. We can now drive the entire Trace in a day and can cover in less than twenty minutes what would have taken them an entire day to traverse.

The start of the Natchez Trace begins at Liberty Road. From Highway 61/84 take Liberty Road east, and you will find the entrance to the Trace clearly marked. Natchez itself is a city with a rich history and considered by more than a few to be an extremely haunted place. I will not spend much time covering the haunted tales of Natchez, as that has been done exceptionally well by Alan Brown in his book, *Haunted Natchez*. A book well worth reading, it is packed with great stories of hauntings, ghosts and legends associated with Natchez.

Some of the haunted stories of Natchez, however, I find to be fascinating, and they are tied in with the Trace and the tales of murder and robbery that go hand in hand with it. Others are merely stories of human tragedy and mourning that, while not directly associated with the Trace itself, are tales worth telling nonetheless.

Two tales of interest originate from the Natchez City Cemetery, a short drive from the start of the Trace and the final resting place of some of the

original citizens of Natchez. Old, discolored headstones dot the cemetery, mixed in with more elaborate and unusual monuments placed in memory of those loved and lost. None, however, is more unusual than that of Florence Irene Ford.

FLORENCE IRENE FORD

Ten-year-old Florence was by all accounts a lovely child who was born on September 3, 1861, and passed away from yellow fever on October 30, 1871. She was very much afraid of thunderstorms, and whenever one would occur, she would rush to her mother's side for safety and comfort. Her mother always gave comfort to little Florence and loved her very deeply, so when Florence passed away, her mother was nearly overcome with grief. She had little Florence's casket constructed with a glass window at the end where her head would lie, and the grave was dug so that a pit the same depth as the casket could be built with steps that her mother could descend. Metal doors covered the entrance to the pit to provide shelter for the mother, and during thunderstorms she would step down into the pit to provide comfort to poor little Florence. According to some, on the nights when the storms crash and the winds howl, cries and whimpers can be heard to this day coming from Florence's tomb. In the 1950s, officials had a concrete wall constructed to cover the glass window of Florence's coffin to protect it from vandals, but the hinged metal doors are still there and fully operational. Reports have it that after violent thunderstorms, you can find the otherwise closed doors standing open as if someone had entered the stairs leading down to the casket. Could the spirit of Florence's mother still be lingering to provide comfort and protection from the storms to the daughter she loved so deeply?

LOUISE THE UNFORTUNATE

Another tale stemming from the Natchez City Cemetery is that of Louise the Unfortunate. No one knows her full name, where she came from or how old she was when she passed, as the only information contained on her headstone is simply "Louise the Unfortunate." It is believed that she arrived in town to be married and that she searched both Natchez-Under-the-Hill and Natchez for her fiancé. This is where the story takes several turns, with one saying that he had died, leaving her stranded without enough funds

to return home, while another states that she found him only to discover that he was already married. Either way, it is evident that she was stuck in Natchez, and by all accounts, she took a number of jobs that would have been considered respectable for a woman of that era.

However, due to unknown circumstances, she eventually drifted down to the rowdy Under-the-Hill section of town and worked as a waitress in the cafés and bars. Her decline continued, and most likely due to desperate circumstances, she found herself working as a "soiled dove" or prostitute in some of the many brothels that were around Natchez-Under-the Hill. The life of a prostitute was hard, and it no doubt took its toll on Louise, both physically and mentally, as I am sure that this was not the life that she had envisioned for herself when she stepped off the boat. She eventually passed away and was buried in the Natchez City Cemetery, but still her story took several turns. One states that a doctor who treated her while she was employed in the brothels paid for her burial, another states that a plantation owner who spent time with her while in town paid for it and yet another story claims that a local reverend paid for her funeral from his paupers' fund. No one knows for sure which story is correct, if any of them are, but one thing is known for sure, and that is that she received a more decent burial than a destitute person would have received, as evidenced by her headstone and burial in the city cemetery. As unhappy as her life would have been, it's no small wonder that sightings of Louise have been passed down through the years, from stories of her weeping apparition walking Silver Street to those who swear that they have seen a woman standing at her grave who suddenly fades away. It's been said by some that if you go to the cemetery on a warm summer night, you can see her standing there weeping, looking at her headstone. Could she be mourning her lost love or simply still in anguish over how her life turned out?

The Devil's Punch Bowl

Just a short drive north on Cemetery Road from the Natchez City Cemetery will bring you to one of the most infamous spots associated with the Natchez Trace and the land pirates. Tales associated with the Devil's Punch Bowl are those of murder and buried treasure, of mistresses buried alive and villains hiding from the law. It has a past associated with nothing but sorrow, so it's little wonder that stories of ghost sightings have sprung up around it.

Mississippi

A geological freak of nature, the Punch Bowl is a deep depression shaped like a cone that sits within sight of the Mississippi River. There are many stories of land pirates faking tragedy to lure unsuspecting river travelers to the Punch Bowl so that they could murder them and make away with their goods.

One of the most famous of the land pirates was Samuel Mason, a captain in the Ohio Militia during the Revolutionary War who, with his gang, used the Punch Bowl as a hideout from the law. By all accounts, he served well in the war and survived an Indian ambush near Fort Henry that decimated most of his company. He even served as a justice of the peace in Washington County, Pennsylvania, before moving on to Kentucky, where for some reason he decided to engage in criminal activity. That decision would lead him to become one of the most feared of the land pirates and would see him operate from Kentucky on down the rivers to Natchez and ultimately the Natchez Trace. Accounts of Mason and his men throwing bodies into the Punch Bowl and then wagering to see which one would hit the water first were often told in those days.

One member of Mason's gang was "Little" Harpe, who, with his brother "Big" Harpe, terrorized the frontier from Knoxville through Kentucky, back down into Tennessee and along the Trace. The brothers were expelled from the gang for being too vicious, having tied an unfortunate victim naked to the back of his horse before running the horse off a cliff to crash into the rocks below. This infuriated Mason and his gang members, I would imagine, not so much because of the unfortunate individual on the horse but because of the loss of a good horse. Little Harpe would later be hanged after he was recognized trying to turn in the severed head of Sam Mason to the authorities to collect the reward offered for him.

Another highwayman to use the Punch Bowl as a hideout was Joseph Thompson Hare, who robbed and killed all along the Trace. He is said to have had his cheating mistress buried alive near the Punch Bowl with nothing but her jewelry. Clearly, he was not a man to forgive her indiscretions.

Stories of both Mason and Hare burying their treasures at the Devil's Punch Bowl have been told for years, and it is a favorite spot for treasure hunters to search. It is also a place that seems to be alive with an energy all its own. Riverboat captains remarked that their compasses would go awry whenever they would pass the Devil's Punch Bowl. Stories of ghosts have been associated with it for many years, with the most well known being that of Hare's mistress. She is said to appear to individuals at night offering her jewels to anyone who will dig her up and give her a decent Christian burial. So

far, it seems no one has taken her up on the offer, as the sightings and stories still persist. The ghosts of Hare and his mistress have also been reported seen strolling around Natchez-Under-the-Hill, laughing and walking arm in arm before slowly fading from sight. Other tales of figures being seen at the edge of the Punch Bowl that seem to shimmer then fade and balls of energy that dart about are told as well. Could these be victims of Mason's gang, still stuck in the spot where they met their end? Or could they be the spirits of Mason and his gang themselves, drawn to the spot that they frequented and where they committed their bloody acts of thievery? No one knows for sure, but one thing is known for certain: the reports of sightings and the feeling of creepiness around the Devil's Punch Bowl are still being talked about to this day.

King's Tavern

King's Tavern is thought to be one of the oldest, if not *the* oldest, buildings in Natchez. The actual date of construction is thought to be around 1798, though some claim that it was in existence as early as 1789 and others claim that it originated in 1769. At any rate, most agree that Richard King is reported to have built the structure after obtaining the property from his brother for the princely sum of fifty dollars. The tavern was used as a gathering place and an inn for weary travelers from the Natchez Trace, as well as the area's first post office.

Local legend has it that King, who was married, reportedly had an affair with a serving girl named Madeline, who by all accounts was quite pretty and lively. When his wife found out about his dalliance, she was understandably less than pleased, and Madeline seems to have disappeared from history at that point. Fast-forward to around 1930, when it became necessary for the owners of the property to do some much-needed repairs to portions of the building. As the story goes, the skeletal remains of two men and a woman were found walled up near the downstairs chimney with a jeweled dagger lying next to them. The theory is that one of them was the serving girl, Madeline, and that Mrs. King had her dispatched with the dagger and then walled up next to the downstairs chimney. No one could venture a guess about just who the two men were, though some thought that they might have been slaves who had vexed Mrs. King at some point, and she had them disposed of. Others thought that they were the actual murderers of Madeline and were dispatched themselves by Mrs. King to cover up the murder.

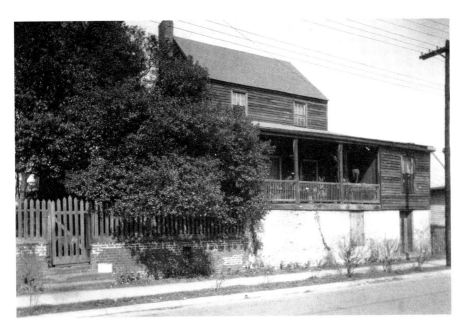

King's Tavern in Natchez, Mississippi, taken in 1934. It's said to be haunted by the ghost of Madeline, Richard King's mistress, who mysteriously disappeared. *Courtesy of the Library of Congress.*

No one really knows, of course, and quite frankly, no evidence of any of it can be proven, but what can be substantiated is that something, or several somethings, are still calling the tavern home. Numerous witnesses have reported seeing the apparition of a young woman believed to be Madeline moving around the various levels of the tavern. Footsteps are heard, jars are knocked from shelves, lights turn on and off and glasses break. Another ghost said to haunt the tavern is that of a man, sometimes seen wearing a hat, and the cries of a baby have been heard within the confines of the building as well. A mirror in the third-floor bedroom will sometimes show the image of someone who is not quite distinguishable, and it is said that if you hold your hand a few inches above the bed, you can feel the warmth emanating from it as if someone has just gotten up.

The tavern is now a popular restaurant, and whether the ghost stories are true remains to be seen, but both staff and visitors alike can vouch that something not of this world makes King's Tavern its home.

UP THE TRACE TO MOUNT LOCUST

Moving up the Trace a short 15.5 miles from Natchez, we come to the turnoff to Mount Locust. A restored home and stand along the Natchez Trace, it is now managed and maintained by the National Park Service. Mount Locust, also known through time as the Chamberlain House and the Mound Plantation, began its storied history around 1780 with John Blommart, who was a successful merchant and fur trader, along with other endeavors, in the Natchez area. He would lead a rebellion against Spain that would cost him his fortune and property, and a business associate of his, William Ferguson, would eventually purchase Mount Locust in 1784. Ferguson would go on to purchase an additional 1,200 acres to add to the original property, and with his wife, Pauline, and their seven children, he would go on to develop it into a plantation.

With the Natchez Trace supplying a steady stream of travelers, it soon became apparent that catering to the needs of travelers could be quite lucrative, so Mount Locust began a portion of its life as an inn. The family prospered, and a short time after William's death in 1801, Pauline married James Chamberlain, an overseer on the plantation, and they raised an additional four children on the property. The family business experienced steady growth, with travelers being offered a meal of corn mush and milk and a spot to sleep on the porch for twenty-five cents. Later, an additional four-room, two-story building was erected some distance behind the house for the purpose of providing lodging to travelers and was given the name of "Sleepy Hollow."

As was the custom of the time, the plantation was built on slave labor, with the 1820 census showing twenty-six slaves residing on the property. By 1850, that number had risen to fifty-one. It is estimated that twelve to sixteen slave cabins housing four to five people each were located a short distance behind the main home. A cemetery on the west side of the property contains the graves of forty-three slaves; a single marker lists the names of some who might be buried there. A short walk to the south of the main home lies the Ferguson Family Cemetery, containing the remains of William Ferguson, four of his six sons, Paulina and two of her sons, with James Chamberlain and a guest, one Robert Law, who died while visiting. It also holds the remains of five generations of the Chamberlain family.

Troops moved up and down the Natchez Trace during the Civil War, and Mount Locust's location, close to both Natchez and the Mississippi River, saw them camping all around the property.

The Civil War brought an end to slavery, and the plantation slowly started slipping into decline. Without slaves to do the work, property was eventually sold off, a little here, a little there, as happened with a number of plantations all throughout the South. All in all, the plantation remained in the Chamberlain family until 1944, and restoration on the home and property began around 1954 with the National Park Service returning the home to its 1820 appearance.

Thousands of men passed through Mount Locust while traveling the Trace, some never to return home. Generations were born and died at the plantation, both slaves and members of the Ferguson/Chamberlain family, so the property saw a lot of suffering and death that have apparently left their imprints on the place.

Stories of workers seeing an elderly lady, believed to be Pauline, started being passed around after the National Park Service started renovations on the property. She would be seen standing on the porch, only to suddenly disappear when noticed. Tools would be moved or go missing, only to turn up in unlikely spots or somewhere that had already been searched. At dusk, figures would be seen moving in the area that used to house the slaves, but

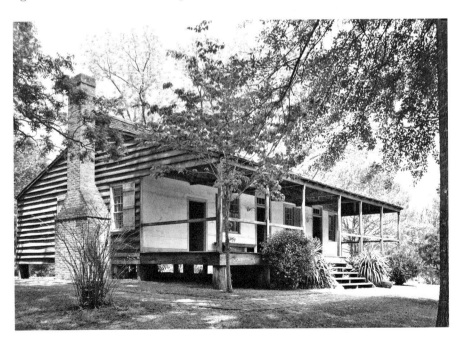

Mount Locust Inn, the only remaining stand site in Mississippi, is maintained by the National Park Service. Built around 1780, it was the first inn that travelers would have passed on their way north along the Trace. *Courtesy of the Library of Congress.*

upon further examination, no one would be found present. Soft, low singing could frequently be heard, though its source could never be determined. Mysterious lights would be seen in the vicinity of both the slave and the Ferguson family cemeteries, only to slowly fade away upon approach.

A place like Mount Locust is home to a lot of history and was a beloved home for five generations of one family. It's quite possible that some of them loved it so much that they have chosen to stay, even after death.

THE (NEARLY) GHOST TOWN OF RODNEY

Just up the Trace from Mount Locust and roughly ten miles west of the Natchez Trace stands the town of Rodney, Mississippi. Once a bustling city and river port, the town is now a shade of its former self. Some refer to it as a ghost town, and while undoubtedly ghosts remain, there are still a few live bodies that call Rodney home.

In a letter written by John A. Limerick, who owned Limerick & Company, druggists and booksellers in Rodney, to a Professor J.A. White of the Agriculture College of Mississippi dated August 16, 1901, Mr. Limerick gives us an interesting account of the history of Rodney. Mr. Limerick moved to Rodney in 1857 to engage in the business of a druggist and died at his home in Rodney on July 12, 1908, so he was a firsthand witness to the heyday and then subsequent decline of Rodney.

The area around Rodney began its existence under the name of Little Gulf sometime around 1765 and then later on as Petit Gulf. In 1825 (1814 by some accounts), the formal town of Rodney was laid out and named in honor of one Judge Thomas Rodney, who at the time was a territorial magistrate. The village was dogged by bad luck throughout its life, and Mr. Limerick notes that the town was almost completely destroyed by fire twice, once in 1852 and again in 1869.

In addition to the fires, the once-bustling river port fell victim to the fickle Mississippi River as the formation of a sand bar around 1864 changed the course of the river, moving it at the time of Mr. Limerick's account nearly a mile and a half from the city. What was once deemed to be the busiest port between New Orleans and St. Louis suddenly started to slip into decline.

One of the best-known stories of Rodney happened during the Civil War, after the fall of Vicksburg left the Mississippi River in Union control. The USS *Rattler*, an ironclad gunboat stationed in Rodney, had the unfortunate

distinction of having most of its crew captured by a small troop of Confederate cavalry. According to the account given by Mr. Limerick, in the latter part of the summer of 1863, Reverend Baker, who was the pastor of a Presbyterian church at Red Lick, Mississippi, decided to resign his position due to his feelings of dedication to the Union. He came to Rodney to wait for a boat to carry him north, and while there, he stayed as the guest of Acting Master E.H. Fentress, who was in charge of the USS *Rattler*. On or around September 12, 1863, an invitation was extended to Reverend Baker by the Reverend Robert Price, then pastor of the Rodney Presbyterian Church, to come and preach the gospel at his church that Sunday. Reverend Baker accepted, of course, and being the considerate Christian gentleman that he was, extended the invitation to the acting master of the *Rattler* to accompany him for the service. Speculation, of course, abounded as to whether or not this was a setup designed to get the crew off the *Rattler* and into the confines of the church, where they could be captured, but like most speculation and conspiracy theories, it has never been proven.

Acting Master Fentress and approximately twenty men accompanied the reverend, and during the services, a Lieutenant Allen and his troop of Confederate cavalry surrounded the church and called for the surrender of the Union sailors. A brief gun battle ensued in which a sailor was slightly wounded before the Federals, knowing that they were resisting in what would be a lost cause, surrendered to the Confederate cavalry. As the locals were getting ready to go home, the *Rattler*, learning of the capture, began shelling the town, a round of which struck the Presbyterian church. After the Confederates had moved away with their prisoners, the remaining crew of the *Rattler* came ashore with the intent to burn the town to the ground in retaliation. Word of this plan reached Lieutenant Allen, who immediately sent word that the town was not responsible for what had occurred and that if a single shell hit the town, he would start hanging his prisoners. That seemed to have the desired effect, as the remaining crew of the *Rattler* retired to their ironclad and sailed off to report what had happened. The crew of the USS *Rattler* went down in history as the only gunboat crew to be captured by a cavalry troop—not exactly what you would like to be remembered for.

With the end of the Civil War and the changing flow of the Mississippi River, Rodney slipped into decline, and this city that in 1860 had boasted a population of around four thousand souls became a shadow of its former glory and prosperity. In the 1870s, the city, hit by economic hardship brought on in part by Reconstruction, tried to rally to save itself, but with the river traffic gone, it simply did not have a lot of options. Then it made

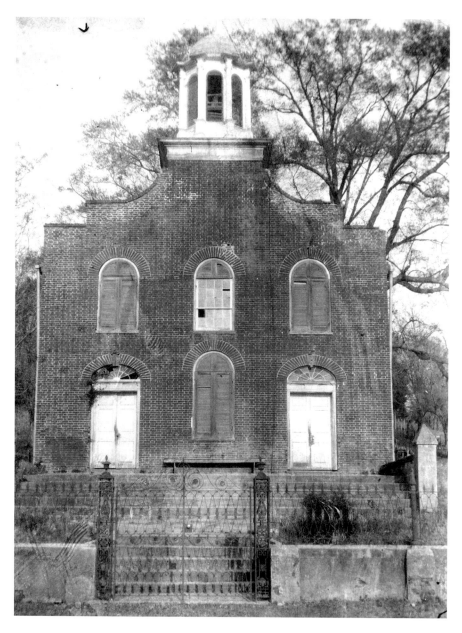

Photo of the Presbyterian church in Rodney, Mississippi, taken in 1936. This is the site where most of the crew of the gunboat USS *Rattler* was captured by Confederate cavalry while attending church services in 1863. *Courtesy of the Library of Congress.*

a really bad decision that drove home the final nail in the coffin of Rodney; it said no when the railroad wanted to come through the city. Without a railroad and no river port, there wasn't much hope that Rodney would ever regain the economic status that it enjoyed prior to the Civil War.

Like most towns that have been in existence for the amount of time that Rodney has, it has seen its share of sorrow and tragedy. Yellow fever struck the town several times, most severely in 1843, which saw numerous deaths and a near depopulation of the city. Anyone able to leave the town packed up and did so. Stores closed, and quarantine was imposed on boats stopping at the port. Those who were too sick to leave either died and were quickly buried or were attended to by those who were too strong or too compassionate to leave their friends and neighbors to face the disease alone. Many of the dead are entombed in the Rodney cemetery, as are the victims of several accidental deaths and one lynching.

R.S. Emerson was taken by a mob and hanged from a tree in the jailhouse yard on February 14, 1890. He was buried in the Rodney cemetery, and supposedly his specter walks the town and graveyard at night, obviously

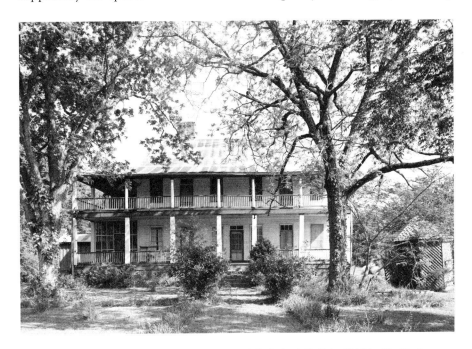

The Laurel Hill Plantation House near Rodney, Mississippi. Built in 1815 by Dr. Rush Nutt, the developer of the Petit Gulf strain of cotton that became popular in the 1830s, he was also the first to use steam power to operate cotton gins. The home was placed on the National Register of Historic Places on January 29, 1973. *Courtesy of the Library of Congress.*

upset with his lynching. Two deaths occurred in 1908. A Mr. E. Higgins was floating logs in the Frasier Swamp for the Southwestern Lumber and Box Company when he accidently drowned. Walker N. Riviera, a well-to-do young gentleman from New Orleans who was visiting friends in Rodney, drowned in Dowd's Creek after trying to cross it on horseback. Despite being warned repeatedly not to try and cross the deep creek, he plunged forward regardless and met his death in the backwater currents, unable to be rescued in time by his friends. Both men are said to still be lingering in the area, and a widely told story from the 1920s and 1930s says that the figure of a man, believed to be Mr. Higgins, had been seen standing on the water of Frasier Swamp with his arms outstretched and his mouth wide open as if calling for help before slowly sinking beneath the surface.

Oakland College, now known as Alcorn University, began its life as a product of the forward-thinking citizens of Rodney. Dr. Jeremiah Chamberlain, who built the Presbyterian church in Rodney, became the president of Oakland College and by all accounts was extremely attached to the place, and some say he still is. Tensions formed by the upcoming Civil War fueled written protests by students, protests that some people claimed the college itself was supporting. These accusations were of course denied by Dr. Chamberlain, both verbally and in writing, but people, then as now, loved to talk and speculate, which did nothing more than continually fan the flames of discontent.

The tensions continued until September 5, 1851, when a Mr. Brisco, who worked at the college, pulled his buggy up in front of Dr. Chamberlain's house. Calling for Dr. Chamberlain to come out, the good doctor obliged and came out to lean on the gate and converse with Mr. Brisco. An argument stemmed from the meeting, though those present would later remark that Dr. Chamberlain remained calm and almost seemed mildly amused at Mr. Brisco's accusations, which quickly escalated into a physical altercation. Reportedly, Brisco leaped from the buggy and began to strike Chamberlain with a whip, knocking him to the ground. The enraged Brisco then pulled a knife with an eight-inch blade and plunged it into Dr. Chamberlain's chest. Chamberlain's son-in-law came running from the house to render aid. Brisco quickly departed to a neighbor's home, where he spun a wild tale about Dr. Chamberlain assaulting him and saying that he was forced to draw his knife in self-defense. The fact that Brisco did not have a mark on him to indicate that he had been assaulted did not lend any credence to his story. Meanwhile, Dr. Chamberlain was being helped into his home by his son-in-law but

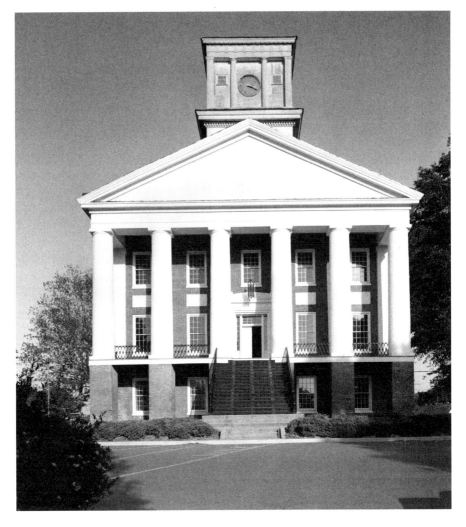

Photo of Oakland Chapel on the grounds of Alcorn University, taken in 1972. Oakland Chapel contains the wrought-iron staircase from the Windsor Plantation, which burned to the ground in 1890. *Courtesy of the Library of Congress.*

only made it as far as the hallway before collapsing, his wife and family rushing to his side as he faded away.

Two days later, Brisco was found dying in the swamp, portions of his body colored black, believed to have been the result of his taking poison. The ghost of Mr. Brisco is said to haunt the swamps and property of Oakland College to this day, doomed to wander the grounds for all eternity in penitence for his murder of Dr. Chamberlain. The ghost of

the good doctor is also said to be roaming the grounds and buildings of his beloved university, still watching over it. Students have reported seeing a man in period clothing walking the hallways and looking through the doorways of classrooms. He is in spirit, much as he was described as being in life, quite benevolent, and those who have seen him have noted a sense of protectiveness emanating from the old doctor that leaves them with a feeling of peacefulness rather than one of fright.

THE WINDSOR RUINS

Situated a few miles north on the Trace and a few miles to the west stand the remains of what was once described as the most opulent example of Southern elegance. Built between 1859 and 1861 at a cost of approximately $175,000, it was the home of wealthy planter and landowner Smith Coffee Daniell II and his family. Sadly, Mr. Daniell would live in the home for only a few weeks before dying there at the age of thirty-four. The bricks for the home were crafted at a kiln across the road from the home site by slave labor, and finish craftsmen were brought in from as far away as New England to work on the mansion. Four stories tall, the home boasted its own commissary, doctor's office, school, kitchen and storage areas along with a dairy on the bottom floor. The second floor was said to house a library, parlors, dining room and a bedroom and bathroom with an attached study. The third floor was home to an additional eight bedrooms and a bathroom, and tanks in the attic supplied water to the bathrooms. The fourth floor was an observatory where Confederate soldiers would send signals across the Mississippi River to troops stationed in Louisiana, warning of advancing Union soldiers. All in all, the entire mansion contained a reported twenty-five rooms with twenty-five fireplaces, though all that remains today are twenty-three Corinthian columns and the iron balustrade that joins them. The stately mansion was not the victim of the Civil War. In fact, it was spared the fate that other plantation owners' homes were forced to face.

The home was the site of extravagant parties after the Civil War and hosted many famous guests, such as Mark Twain, who wrote about the mansion and its elegance in his book *Life on the Mississippi.* He was reported to stand in the observatory for hours watching the river and contemplating.

The home was also used as a Union observation post and as a hospital for wounded and convalescing soldiers during the war. This, along with General Grant's obvious affection for the place, most likely saved it from being

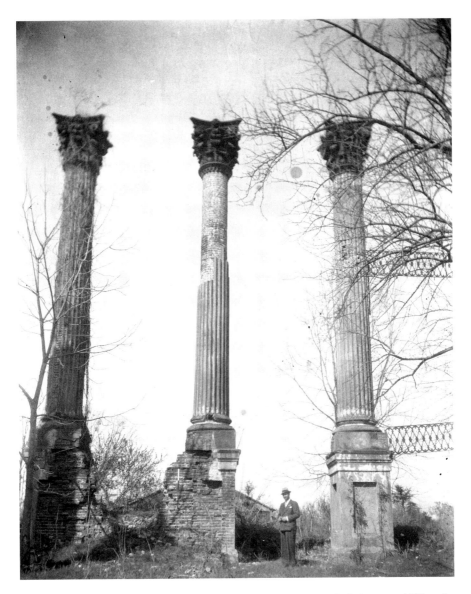

Photo of the west wing columns of Windsor Ruins, taken in 1936. Built between 1859 and 1861 by Smith Coffee Daniell II for a cost of approximately $175,000, in today's currency it would have cost slightly more than $3 million to build. It was once described as the most opulent example of southern elegance. It burned to the ground when a careless party guest left a burning cigar on the third-floor balcony. *Courtesy of the Library of Congress.*

burned to the ground. The fact that it would survive the war and the fires that consumed other Southern mansions only to be burned to the ground by a careless smoker during a party in 1890 merely adds to the tragic loss. All of the known photos and plans for the home were lost during the fire, and much of what we know about the house was passed down from firsthand accounts of people who had visited and stayed at Windsor. It wasn't until a drawing was discovered in the Ohio State Archives belonging to a Henry Otis Dwight, who was an officer in the Twentieth Ohio Infantry, that we had an actual idea of what the mansion would have looked like from the outside during the 1860s. It is the only known depiction of Windsor thought to be in existence today.

The property remained in the family until 1974, when it was given to the Mississippi State Department of Archives, and the state has maintained the property as a historic site ever since. When traveling to the ruins on State Highway 552, you will find a sign pointing the way down a dirt road, weeds choking the sides of the ditches. The grounds around the columns are well cared for, though, and the columns are roped off to ensure the safety of visitors. A short drive away from the ruins sits the

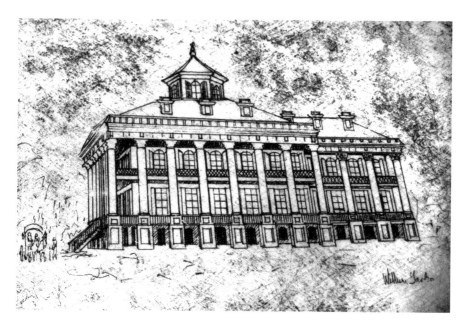

Drawing of the Windsor Plantation home thought to be an accurate depiction of what the mansion looked like before it burned. The drawing is part of a sign next to the ruins maintained by the Mississippi Department of Archives and History. *Photo by Jennifer Steed.*

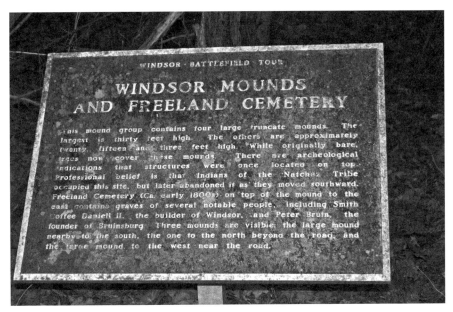

WINDSOR · BATTLEFIELD TOUR

WINDSOR MOUNDS AND FREELAND CEMETERY

This mound group contains four large truncate mounds. The largest is thirty feet high. The others are approximately twenty, fifteen and three feet high. While originally bare, trees now cover these mounds. There are archeological indications that structures were once located on top. Professional belief is that Indians of the Natchez Tribe occupied this site, but later abandoned it as they moved southward. Freeland Cemetery (Ca. early 1800s) on top of the mound to the east contains graves of several notable people, including Smith Coffee Daniell II, the builder of Windsor, and Peter Bruin, the founder of Bruinsburg. Three mounds are visible: the large mound nearby to the south, the one to the north beyond the road, and the large mound to the west near the road.

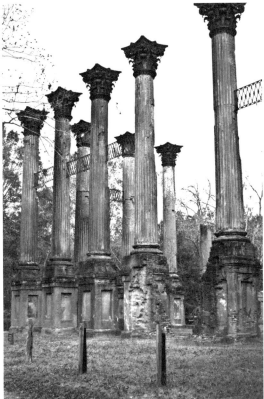

Above: Sign marking the entrance to the Windsor Mounds and Freeland Cemetery, where Smith Coffee Daniel II and descendants are buried. *Photo by Bud Steed.*

Left: The remains of the columns at Windsor Ruins, taken in November 2011. The ruins are roped off for safety due to the columns' having become unstable over time. *Photo by Bud Steed.*

family cemetery, where numerous descendants of Smith Coffee Daniell II, along with the man himself, rest for eternity. Lights are said to be seen moving about the family plots just as night overtakes the area, but upon close investigation, no one or nothing can be found that accounts for them. A Union soldier was shot to death in the doorway of the mansion, and the reason behind his death is unknown. His ghost is said to be seen walking up the nonexistent stairway to the main floor at various times of the day, only to fade away at what one could only guess would be the landing. In the evenings, it's said that the sounds of laughter and music can be heard floating on the wind, the remnants of some long-ago party, perhaps. The sounds seem to wrap themselves around you, and you can almost imagine the people dancing and gliding around the floors that once stood between the columns. The apparition of a man in period clothing has been seen walking the grounds, and one observer thought that a reenactor was present, but when he approached the man to ask him a few questions about Windsor, the man reportedly turned to face him, smiled and then faded from sight. One wonders if it might not have been Smith Coffee Daniell II himself, still overseeing the home where he lived only a few short weeks before dying. Either way, the Windsor Ruins have been the origin of several stories of paranormal activity throughout the years, and if you are ever there in the evening, just as night is about to fall, listen closely for the sounds of music; you just might find yourself attending a party where you are the only living soul.

HISTORIC PORT GIBSON

Port Gibson sits along the Natchez Trace and was originally chartered as a town on March 12, 1803. It also holds the distinction of being Mississippi's third-oldest settlement, having been continually occupied since 1729. Named for its founder, Samuel Gibson, it remains the county seat of Claiborne County and is a very pretty sleepy little southern town. It was, at the time of its founding, a welcome sight to travelers on the Natchez Trace who would find food and shelter in their travels and a safe place to spend the night before moving homeward. It had the usual life of many small southern towns in the 1800s, with outbreaks of yellow fever claiming a few lives and the normal life and death of its occupants, but overall, it seemed to maintain an even keel and a modicum of good luck not favored by its neighbor to the south, Rodney. The town escaped being burned by

Bayou Pierre Presbyterian Church, established in 1807, was part of the line held by the Confederate troops during the Battle of Port Gibson. The Twentieth Alabama Infantry was posted here as part of General Tracy's right flank. *Photo by Bud Steed.*

Federal forces during General Grant's push to capture Vicksburg, so it retains much of its historic architecture and southern charm. Port Gibson saw the movement of troops during the Civil War as the armies of both sides made use of the Natchez Trace to move supplies and men to and from battle sites. Several skirmishes and battles were fought around the area, the most important one being the Battle of Port Gibson, which started a few miles south near the A.K. Shaifer House on the Old Rodney Road. The house still stands today, complete with bullet holes in the walls, as a testament to the fight that produced approximately 861 casualties for the Union forces and 787 for the Confederates and paved the way for Grant's eventual capture of Vicksburg. The A.K. Shaifer House served as the headquarters for General McClernand's command and as the Union hospital during the battle. The old Magnolia Church, which was the Confederate's first line of defense, is no longer standing, although the brick foundation and cistern still remain and are easily found. Much of the terrain, with its deep vine-covered ravines and steep ridges, is still pretty much as it was when the armies engaged each other, and relics of the battle are still occasionally being found.

The residents of Port Gibson take pride in their town and in their heritage, and it clearly shows as you traverse the town. Restoration and upkeep of the historic buildings and homes is evident, and an annual Heritage Festival is held the last weekend of March each year.

Port Gibson has several cemeteries with reported ghostly activity, the most famous being the Wintergreen Cemetery, which was originally the family burial grounds of Samuel Gibson, the town's founder. Sightings of orbs, or balls of light, occur in the cemetery late at night, as do floating mists that seem to rise from the graves a few feet into the air and then fade slowly from sight. The black misty figure of a man has been reported walking among the graves at night in the older part of the cemetery, only to suddenly disappear if approached.

Figures of Civil War soldiers are seen on the Old Rodney Road, near where the old Magnolia Church used to stand and in and around the A.K. Shaifer House. Sounds of musket and cannon fire can be heard faintly as if from a great distance, and this noise seems to come from all sides. The sounds of troop movements and orders being shouted can be heard, but once again, they sound as if they are coming from a great distance away

Photo of the G.L. Disharoon house, located in Port Gibson, taken in 1936 as part of the Historic American Buildings Survey. *Courtesy of the Library of Congress.*

and from all around you rather than from one direction. If you sit quietly near the foundation of the old church, you can faintly hear men talking in whispers; unintelligible voices but clearly men talking. At night, the sounds of men crying out and moaning in pain have been reported in the vicinity of the Shaifer House, while whispering can be faintly heard inside the house, only to stop when someone enters the room. A woman in white has been seen both inside and out at the Shaifer House and has appeared in several photos that have been taken of the home. She seems to be indifferent to her surroundings and doesn't seem to interact or acknowledge anyone's presence when she is spotted. She is believed to be Mrs. Shaifer, the former owner of the home and its occupant during the Battle of Port Gibson.

All in all, Port Gibson is a nice little town with a rich history, and I would highly recommend making the stop while you're traveling the Trace. And if you take a drive down the Old Rodney Road, be sure to keep a watch out for any soldiers who might still be fighting the Battle of Port Gibson.

The Sunken Trace

Just a few miles north of Port Gibson on the Natchez Trace, you will find an old section of the Trace kept much the same as it was in the days when the Kaintucks and others traveled it. Worn, compacted and sunk deep into the soft Mississippi loess soil, some sections of the bank on each side of the roadbed are higher than a man's head. Trees line the sides, and thick vegetation crowds the road, making it easy to imagine land pirates lurking in the shadows, waiting to fall upon tired, unsuspecting travelers to rob and murder them. There are several sections of the old Trace maintained much as this one, and they all seem to share the same legend: that of Big Harpe's head.

The frontier from Knoxville, Tennessee, over to Kentucky and on south down the Natchez Trace was terrorized by a pair of brothers named Harpe, known as "Big" and "Little." In all actuality, as near as can be determined by historical research, they were actually cousins who shared the same last name of Harper and who, after the Revolutionary War, dropped the "r" from their last name to attempt to distance themselves from their misdeeds. They were Tories, loyal to King George during the Revolutionary War and known members of "rapine gangs," those who were not enlisted in actual military service but who resorted to a sort of terrorist tactic of stealing, burning and murdering those opposing British rule. They further refined their murderous

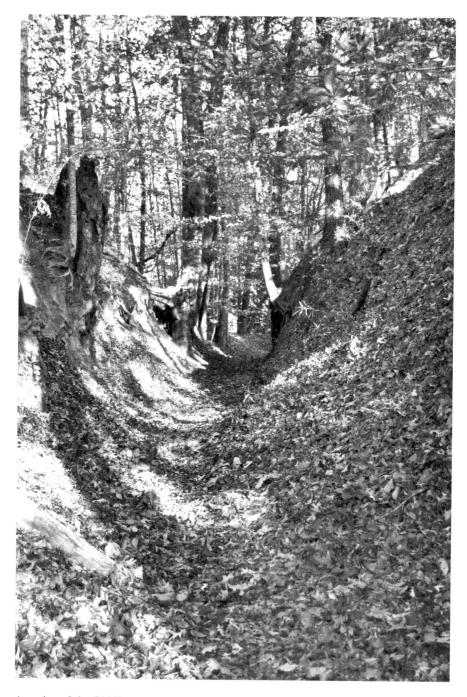

A section of the Old Trace referred to as the Sunken Trace near Port Gibson. The passage of thousands of people over time has compacted the soil, leaving the banks of the Trace well above a person's head. *Photo by Bud Steed.*

trade while living with members of the Cherokee tribe at Nickajack Village near modern-day Chattanooga. The Cherokee of that area were loyal to the British, and the Harpes lived with them, murdering settlers all up and down the frontier from their base of operations at Nickajack Village. Eventually, the settlers got tired of the constant threat and banded together to launch an attack against the village. Word spread of the impending attack, and the Harpes, with their women in tow, beat a hasty exit from the area, moving north toward Knoxville.

True to their nature, they were not able to stay out of trouble for long, and soon their stealing brought the attention of the local authorities; they once again moved on, this time heading westward. All along the frontier, they killed and robbed anyone they met, be it man, woman or child, and Big Harpe is even credited with killing his own baby because its crying kept him awake. He reportedly grabbed it by its feet and swung its head into a tree, bashing its brains out, though some accounts say that he murdered the baby by swinging it into the wall of a cave where they were hiding out.

Needless to say, the Harpes were merciless and remorseless killers, sometimes killing for the sheer pleasure that they derived from it, and they are credited with the known murders of forty men, women and children. Their preferred method for disposing of a body was to disembowel the corpse, fill the body cavity with rocks and then sink the body in a deep river or creek. This would later become the preferred method of other land pirates and highwaymen frequenting the Trace. Lacking water to dispose of the evidence, they would resort to dismembering the bodies and dropping them down sinkholes and into caves.

In July 1799, a posse was raised to pursue the Harpes after their murder of Mrs. Stegal, her baby and a guest who was staying with her. As the story goes, the Harpes came to the Stegal cabin seeking food and shelter and were told that they would have to share the loft with a Major William Love, who was lodging with the Stegals for the night. According to legend, at some point in the night, the Harpes killed Major Love simply because he snored too loudly. Upon waking, they offered to watch Mrs. Stegal's infant while she prepared breakfast for everyone, telling her that Major Love was still asleep. While she fixed breakfast, they slit the infant's throat in its crib and, once breakfast was ready, murdered Mrs. Stegal as well. They pillaged the home, taking what they wanted and left. Later, Mr. Stegal arrived and found his family murdered, and along with his neighbors, he set out to track down the killers. They surprised the Harpes while they were camped, and in the initial attack, Little Harpe escaped and Big Harpe was wounded, though he

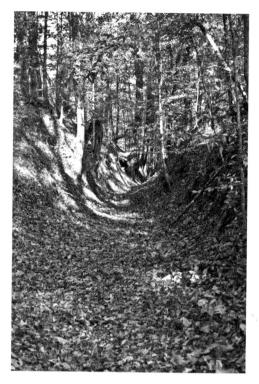

Another section of the Sunken Trace near Port Gibson. *Photo by Bud Steed.*

managed to get on a horse to try to evade the posse. Eventually, he was run down and shot several times, with one bullet apparently paralyzing him. The distraught husband of Mrs. Stegal, one Moses Stegal, approached Big Harpe, took Harpe's own knife, showed it to him and then proceeded to cut off Big Harpe's head while he was still alive. The head was then stuck in a fork of a tree along the roadway as a warning to other murderers and thieves of what they could expect should they try and ply their villainous trade in those parts.

As the legend goes, this reportedly happened along the Natchez Trace south of Nashville, though others say it occurred just north of Natchez. Still others claim it happened in Kentucky and point to the area known as Harpe's Head as proof. But regardless of the location, the story told is that the head of Big Harpe remained in the fork of the tree for several years before being reduced to only a grinning skull. An old witch woman who lived near the Trace supposedly stole the skull one night and ground it into powder to be used in her spells and potions. It's said that if you walk out on a section of the old Trace and retell the story of Big Harpe losing his head, you will hear cackling laughter coming from the brush near the Trace, reportedly that of the witch delighted with the story of her theft of the skull.

I visited the section of the Trace just north of Port Gibson known as Sunken Trace just to see if there was any validity to the story. It was a warm summer evening when I took a walk down the Trace by myself, with not another living soul to be seen along the roadway. As it started to grow darker, I stopped and retold the story of Moses Stegal decapitating Big Harpe and the later display of his head along the roadway. As I finished telling the part

about the witch stealing the skull and her grisly usage of it, I swear I could hear muted laughter coming from the woods and rustling in the leaves on the forest floor. It could have been my overactive imagination, or it could have been the old witch reveling in the tale. Either way, I beat a hasty retreat back down the Trace to the relative safety of my car. Discretion, as they say, is the better part of valor.

The Ghost Town of Rocky Springs

The ghost town of Rocky Springs can be accessed from mile marker 54.8 on the Natchez Trace, and the town was established about 1796 because of its natural spring, which was supposed to produce a steady flow of good, sweet water. People slowly moved into the land around Rocky Springs, and a man named Isaac Powers built a tavern that would shelter travelers on the Trace for many years, eventually becoming the post office. By 1837, the settlement would boast several stores, the post office, the tavern and a church, and in 1838, the first private school, named the Rocky Springs Academy, was opened. Many of the bricks crafted for the Methodist church were baked in a kiln near the town. The church, built in 1837, still stands today, and while no one lives in the town, services are still held at the church every Sunday morning, just as they have always been.

The town and surrounding area continued to grow, and by 1860, in the twenty-five-mile radius of Rocky Springs, there was a population of nearly 2,600 people. This broke down to include 3 preachers, 3 storekeepers, 4 teachers, 4 doctors, 13 artisans (blacksmiths, carpenters and the like) and 54 planters who employed 28 overseers to control and manage the over 2,000 slaves who worked the area plantations.

Rocky Springs began its slow decline during the Civil War, with battles and troop movements taking their toll on both the land and the residents' supplies and property. General Grant, along with his staff of officers, made Rocky Springs his headquarters during May 1863. His army of forty thousand men camped less than a mile away, on Little Sand Creek. In 1878, an outbreak of yellow fever took the lives of thirty-seven people during the summer and fall. Most of them are buried in the Rocky Springs Cemetery, located behind the Old Methodist Church.

Several reasons are cited for the demise of the town. The arrival of the boll weevil in the early 1900s almost completely destroyed the cotton industry, and high taxes and the town's remote location added to its

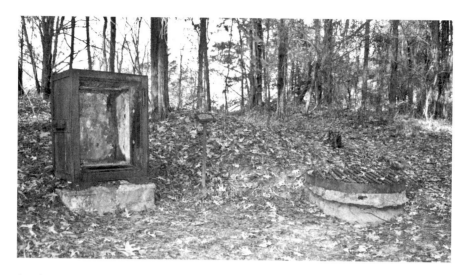

An abandoned safe at the ghost town of Rocky Springs, which was established in 1796. A thriving village of 2,600 people in 1860, all that remains today are two safes, a couple of cisterns and the church. *Photo by Bud Steed.*

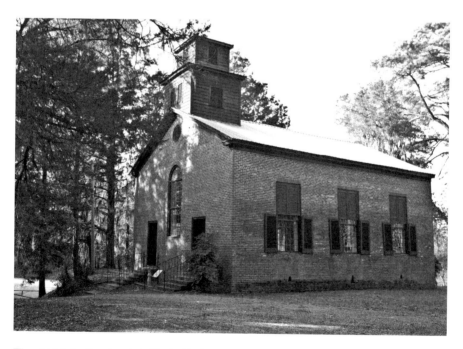

The old Methodist church in Rocky Springs was built in 1837. Even though very little remains to mark where the town once stood, the faithful congregation of the church meets every Sunday, just as it has since the church was built. *Photo by Bud Steed.*

problems. Most significant though was the erosion of the soil, due to one hundred years of poor land management and the drying up of the springs for which the town was named. In the 1930s, the last store closed, and nothing remained except for a few people too stubborn to leave. Eventually, even they died off or moved on, leaving a few old relics, the church and a cemetery to mark their passing.

Walking around the old town site, you can't help but feel as though you are being watched. Perhaps it's just the known fact that so many people lived and died here over the years, each with their own hopes and dreams for the future. Some saw those dreams fulfilled, while others saw them wither and die, left with the bitterness of what might have been. It's a curious mixture of both who seem to still remain in the old town—the ghosts, that is. Some, like the voice of the lady who is said to whisper to you as you walk through the cemetery at night, seem to offer no harm to anyone. It's almost as if she is trying to tell you something but can't quite speak loud enough to make herself heard. Others seem simply to want to be left alone, like the unseen spirit who likes to get physical with people, pushing and scratching while remaining unseen, sometimes in the graveyard or sometimes on the trails. Mostly, he seems to focus his attentions on those who come looking for a thrill, searching for some proof that the spirits of Rocky Springs are indeed still there; obligingly, he gives them what they want so they will leave. Mists and balls of light that flit back and forth among the tombstones have been reported as well.

One other story about the cemetery that seems to have been experienced by several people down through the ages is that of the apparition of a young girl. Thought to be about seven or eight years of age and dressed in the period clothing of the late 1800s, she appears as an almost life-like figure. Most people report seeing apparitions as misty or not quite solid, but everyone who has ever seen the child thought that she was an actual living and breathing girl. She seems to be playing around the tombstones, darting in and out around them, giggling and carrying on like a normal little girl. She even turns to look at you when you call out to her. No one knows her name or her story, and she never seems to disappear in the same spot, though she has never been seen outside of the graveyard itself. One minute she is running and playing, and the next minute, almost as if you blink your eyes and she's gone, no trace can be found of her.

There is a campground at Rocky Springs run by the park service that offers overnight camping for those wishing to stay in the area. Many campers have reported hearing the sounds of footsteps around their tents

and motor homes at night, but no one is ever seen. One story in particular shows the rough humor of the nighttime walker. A bicyclist who, with a group of friends, was riding the Natchez Trace reported that he and his friend heard those footsteps late at night. It was an extremely dark night, and thinking that it might be another of his party having trouble coming back from the bathrooms, he rolled out of his tent and shined his flashlight all around. No one was to be seen anywhere though, and when he turned to get back into his tent, he felt what could only be described as a swift kick to his backside, knocking him headfirst into the tent and on top of his partner. Shock, and then anger followed, with the gentleman and his friend both piling out of the tent to see who the practical joker was, but upon investigation, including

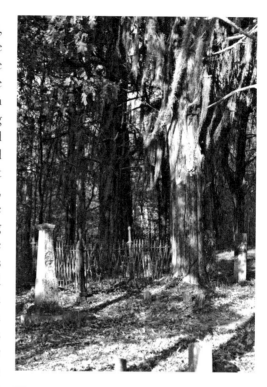

The cemetery located behind the Methodist church in Rocky Springs is very old, with headstones dating back to the early 1800s. It is the site of several ghost stories, and walking through the cemetery, it is easy to see why; weeds and broken headstones choke areas of the cemetery, lending to the eerie feeling of loneliness. *Photo by Bud Steed.*

accounting for all of his party who were safely in their tents, no one could be found. Perplexed, they retired once again to their tent, first the friend and then the gentleman who was booted into the tent. Once again, as he bent over to get into the tent, he received the same swift kick that he had gotten before. This time, however, it was followed by a deep, throaty laugh. The interesting part was that the friend was sitting just off to the side of the doorway holding the tent flap open and couldn't see anyone there at all. The story goes that they remained awake in the tent for the remainder of the evening and, at first light, beat a hasty retreat back down the Trace and away from Rocky Springs. I guess even spirits like a bit of slapstick humor at times.

Raymond and the Battle of Raymond

At milepost 78.3 on the Natchez Trace stands the exit for the town of Raymond and for the military park commemorating the Battle of Raymond. On May 12, 1863, General Grant's forces drew fire from Confederate forces led by Brigadier General John Gregg about three miles south of the town of Raymond. After his victory at Port Gibson, Grant was determined that he should take Jackson, shut down the railroad and effectively cut off supplies to Vicksburg, so he started marching his 12,000 men along the Natchez Trace toward that objective. He ran into General Gregg's men at Fourteen Mile Creek, and the Confederates, thinking that they were facing a much smaller force, attacked with their 4,000 men, charging across the creek and straight at the Union soldiers. Outmanned 3 to 1, the Confederate troops fought bravely for nearly six hours, but eventually the heavy artillery fire and sheer numbers pressed them back until they were forced to leave the field. They left behind their dead, dying and those too severely injured to move on the field of battle as they retreated toward Jackson. Union forces occupied the town of Raymond and the battlefield for the remainder of the night, and the courthouse, homes, churches and even a hotel were converted to hospitals, with the wounded from both sides, estimated at nearly 1,000 men, cared for by the citizens of Raymond. Bloodstains can still be seen on the floor of St. Mark's Episcopal Church. The approximate number of casualties was thought to be around 514 for the Confederates and 442 for the Union. The 140 Confederate soldiers who perished there that day or later from their wounds are buried in the Confederate Cemetery, and the United Daughters of the Confederacy sold ice cream in 1910 to help pay for an ornate fence and gate that surrounds the burial sites.

The city of Raymond is quite old, dating back to around 1828, and is one of the county seats of Hinds County, along with Jackson. Its proximity to the Trace and its status as the county seat ensured its steady growth, with a new courthouse being built, largely through slave labor, in 1857. The courthouse is recognized by the Smithsonian as one of the ten most perfect examples of southern architecture and is in remarkably excellent condition. There are a number of antebellum homes and Victorian homes in Raymond that have been restored to their former glory and are accessible to tourists and others interested in the period. The entire town is a charming example of southern hospitality, the residents ready and willing to answer any questions about their city and its history.

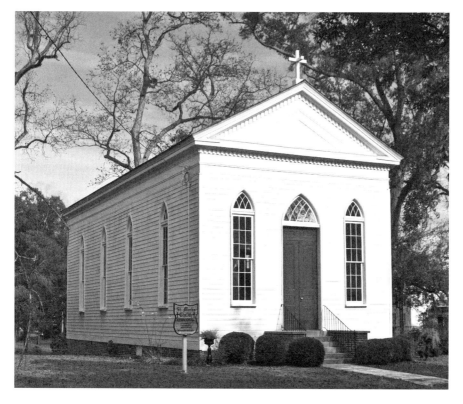

St. Mark's Church in Raymond was used as a hospital after the Battle of Raymond, and bloodstains are clearly seen on the floor to this day. *Photo by Bud Steed.*

On the southern outskirts of town sit the cemeteries, both the local and the Confederate, and they are easily accessible from both the east and west side streets. The portion of the city cemetery dedicated to the Confederate soldiers who died during or immediately after the Battle of Raymond is clearly marked by the iron fencing and ornate gate marked "Confederate Dead." Compared to the rest of the cemetery, this section is very well cared for. The remainder of the cemetery is slowly slipping into decline due in part to its age, with several crypts reduced to rubble or shored up with planking. Numerous headstones reveal dates of death in the early to mid-1800s.

Following the Civil War, the city of Raymond slowly slipped into decline, as did most southern cities when the major source of income, namely farming from plantations, ground to a halt without slave labor to do the work. Most of the plantations faced bankruptcy, and money was in

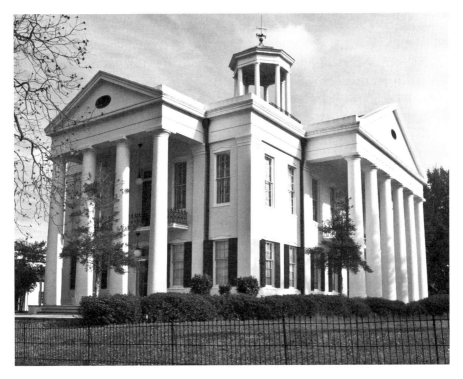

The historic courthouse in Raymond was built in 1857, mostly through the use of slave labor. It has been touted by the Smithsonian as one of the ten most perfect examples of southern architecture. It was used as a hospital after the Battle of Raymond and is one of the county seats of Hinds County. *Photo by Bud Steed.*

short supply all over the South. By the early 1880s, Raymond had staged a comeback, as evidenced by the number of Victorian homes built within the city, testimony to the opulence associated with that era. Hard times struck again, with both world wars creating economic hardship for Raymond, as they did with most of the country, but the city of Raymond struggled on and eventually recovered once again. The city today is well kept, and the citizens' pride in their homes and community is apparent. The sense of history that one can experience simply driving down the street here is nearly overwhelming. Life is old here: the city received its charter in 1830, and several generations of families have lived and died here, the family homes seeing births and deaths, joy and sorrow. Most inhabitants of Raymond are closed-mouthed about ghosts and hauntings and will scoff in a good-natured way at your inquiries or simply decline to speak of it, but there are some stories that have circulated through the years.

St. Mark's Church is reportedly haunted, with figures being seen through the windows even though the building is locked up and empty. Bloodstains are still very visible on the floor from when it was pressed into service as a hospital immediately after the Battle of Raymond, and voices moaning and crying out in pain have been reported emanating from the building late at night. The courthouse, which was also used as a hospital to care for the wounded, has had its share of odd happenings as well, with the sounds of slamming doors coming from otherwise empty hallways, cold spots that sometimes seem to follow you around the building and moving shadows in the evening that can't be explained. Civil War soldiers have been seen around town as well, there one instant, and gone the next, leaving the witness wondering if he actually saw them or not. Sightings of lights and figures that fade away upon approach have been reported in the cemeteries also. The figure of a Confederate soldier, apparently guarding the Confederate portion of the cemetery, has been reported on several occasions, standing watch just inside the gate near the headstones marked "unknown." Soldiers have also been seen along the roadways leading into the city from the battlefield, only to disappear whenever a brave soul would stop to investigate.

Stories such as these are not only common in Raymond, with much of the South experiencing violence and death from the many battles fought there during the Civil War. Sightings of the apparitions of Civil War soldiers are more common than you might think throughout the South. Perhaps the city of Raymond holds its share of lingering spirits simply because of the enormous amount of death and suffering that occurred in its many buildings and homes immediately after the battle. Or possibly the kindness and caring of its residents to those wounded and dying left a lasting impression, binding the spirits to the last place on earth where they felt cared for and safe from the horrors of the war. Most likely we will never know the answer to that, but one thing seems most certain: whatever the reason that they remain, both they and the townspeople seem comfortable with the arrangement.

Cowles Mead Cemetery

Just north along the Trace from Raymond at milepost eighty-eight, you will come to a pull off with a sign marking the way to the Cowles Mead Cemetery, the final resting place of Cowles Mead, his wife and son. Mead was originally from Virginia, and like a lot of men of his time, he went westward seeking his fortune. For a time, he owned and operated a tavern

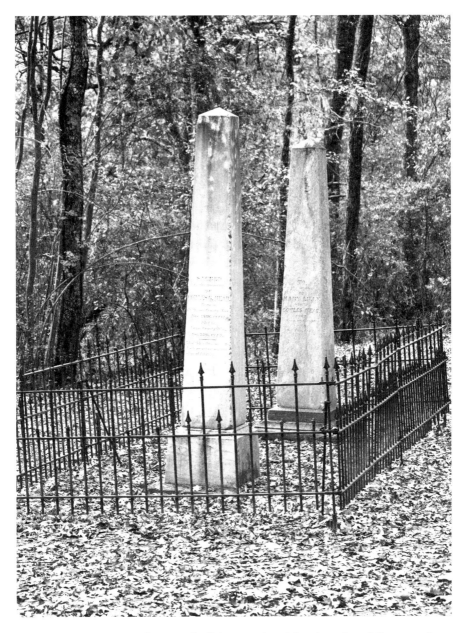

The Cowles Mead Family Cemetery is all that remains of the plantation of Greenwood, built by Cowles Mead, who served as a territorial secretary of Mississippi and acting governor. He issued the order to arrest Aaron Burr for treason and is credited with introducing Bermuda grass to the United States. *Photo by Bud Steed.*

near Natchez on the Old Trace and, from his training as a lawyer, became active in politics. He was said to be a great orator whose addresses were a joy to hear. He later moved close to Clinton, Mississippi, and built a fine home, which he named Greenwood, that, by all accounts, had a beautifully landscaped fifty-acre yard. He was an avid gardener and is credited with introducing Bermuda grass, of which his lawn was composed, to the United States. Among his claims to fame is an appointment as territorial secretary of Mississippi, where he also served as acting governor for a time, and he is famous for ordering the arrest of Aaron Burr for treason. He died in 1844 at his home and was interred in the small family plot near his estate. His home, Greenwood, fell victim to the Civil War and burned in 1863; no trace of it remains today, apart from the small cemetery where he rests.

It is said that if you stop at the wayside and make the short walk to the small family cemetery in the early evening hours, at times you will hear the supposed voice of Cowles Mead giving an address to an unseen audience. It reportedly lasts for only a few moments, and one has to strain to hear the voice, barely more than a whisper at times. Unexplained lights have been seen in the field where the plantation home was said to stand, moving slowly around near the trees close to the family plot. The figure of a man has been seen several times slowly walking from the cemetery, *through* the wire fence, only to disappear a short distance away in the otherwise empty field.

Jackson, Mississippi Area

The next section on our trip up the haunted Natchez Trace includes Jackson, Mississippi, and the area immediately surrounding it, such as Madison and Ridgeland. Jackson itself has a long history, and numerous tales of hauntings are told of this particular spot; so many, in fact, that a book could be devoted entirely to the Jackson area itself. For the purpose of keeping on track with our haunted Natchez Trace trip, though, we will only touch briefly on Jackson and the surrounding areas, detailing just a few of the better-known and more interesting legends of ghostly occurrences.

Jackson

The city of Jackson was first established by Louis LeFleur, a French explorer and trader who would later found French Camp, Mississippi, and was originally known as LeFleur's Bluff. In 1821, the Mississippi General Assembly, at its meeting in the then capital of Natchez, agreed that a more central location was needed for a new state capital. It sent Thomas Hinds, for whom the county was later named, James Patton and William Lattimore to find a suitable site to establish the new capital. It was determined that the exact center of the state lay within a swamp, so the men moved southwest along the Pearl River until they came to LeFleur's Bluff. There they found a perfect spot, with proximity to the Natchez Trace to facilitate trading and travel, abundant timber, good water sources and easily navigable rivers.

They stated as such in their report to the General Assembly, and an act was passed in 1821 that authorized the site to become the permanent seat of government for the state of Mississippi. The name would be changed from LeFleur's Bluff to Jackson in honor of Andrew Jackson and his victory over the British in the Battle of New Orleans.

Around 1840, Jackson was linked to other cities in the area by railroad lines, most notably the one running from Jackson to Vicksburg that would become the target of General Grant's push to cut off supplies to Vicksburg. During the Civil War, two battles were fought for Jackson, one in May 1863, which saw the Confederate forces pushed out of the city and resulted in Union forces under General William Tecumseh Sherman burning and looting some of the key areas of Jackson. After driving out the Confederates, the Union army then moved west toward its objective of Vicksburg. Confederate forces began reassembling in Jackson in an attempt to push through the Union lines and end the Siege of Vicksburg, and they built fortifications encircling the city of Jackson while they prepared to move west.

Unfortunately, they took too long to organize, and Vicksburg fell to the Union before they could march to its aid. General Grant then ordered Sherman back to Jackson to meet the Confederates, and the Siege of Jackson began. Union forces completely encircled the city, and artillery emplacements were established that began shelling the city without mercy. For nearly a week, the battle raged on, until July 16, 1863, when the Confederate forces slipped across the Pearl River to safety during the night. After they withdrew, the Union forces entered the city and completely burned it to the ground, giving Jackson the nickname of "Chimneyville," as only the chimneys of the buildings remained.

Hundreds of lives were lost, both military and civilian, and the only buildings to survive the burning were the Governor's Mansion that served as Sherman's headquarters and the Old Capitol building. Another surviving antebellum structure is the Jackson City Hall, built in 1846. Local legend has it that General Sherman, who was a Freemason, spared the building because it housed a Masonic Lodge, though some think that it was most likely in use as a hospital and that is why it was spared.

An intact artillery emplacement is still located on the grounds of the University of Mississippi Medical Center, and another position remains intact on the campus of Millsaps College. During the siege, the Confederates' northern line ran along a road that is now known as Fortification Street and has been the location of several ghostly sightings.

Mississippi

With the ending of the Civil War, Jackson set about rebuilding itself and has developed into a thriving metropolis, though it has been marked by ups and downs throughout the years. Racial tensions and riots occurred during the 1960s that resulted in Jackson being placed under martial law for a period of a year by order of Congress and President Kennedy. In 1963, just after midnight on June 12, civil rights activist Medgar Evers was murdered in his home in Jackson. In 1967, the Ku Klux Klan bombed the synagogue building of the congregation of Beth Israel, along with the home of Rabbi Dr. Perry Nussbaum, but since that time, over the years, old barriers of hatred and intolerance have slowly receded.

Jackson has been the site of much violence throughout the years, not only from the Civil War and civil rights violence, but from murder as well. As recently as June 2011, a man was beaten to death and robbed by a group of white teenagers in what has been described as a hate crime and is under investigation as a violation of civil rights by the FBI. With all of the bloodshed and death that has happened in Jackson, it's not hard to understand how stories of hauntings and ghostly activity have come about.

The Spengler Street Hotel was the site of three murders between the 1920s and the 1950s, and it is known to more than just a few as a location rife with paranormal activity. Legends state that two of the murders were crimes of passion, one the killing of an unfaithful woman's lover and the other the killing of a man caught in a love triangle. The third, as the story goes, was a bit more gruesome. A man, seeking revenge on another for some perceived slight, entered his victim's room late one night and hit him repeatedly in the head with a hatchet, completely destroying the sleeping man's head, leaving only a grisly pile of bone and brain fragments to mark where it had been. Supposedly, the sounds of something being struck, I would presume the unfortunate man's head, were reportedly heard in the otherwise empty room where the deed was supposed to have occurred. The apparition of a headless body was reported to be seen in the 1960s, as well as a shadowy outline of a headless body. Shadow figures have been seen in the area, and streaks of unexplained light and mists have all been reported from time to time.

Sightings of Civil War soldiers have been reported along Fortification Street, seemingly still enduring the Siege of Jackson. One report was of the ghost of a Civil War soldier seen standing on the sidewalk of Fortification Street, looking about in confusion and bewilderment, as if he was suddenly aware that he was no longer in 1863 Jackson. He supposedly faded from sight, still gawking open-mouthed at what he saw. One wonders if he

was indeed a ghost or whether perhaps the veil between time and space parted for a brief moment allowing him to see what to him would have been the future. The smell of gunpowder is reported from time to time, as are undistinguishable voices that seem to come from all around a person but can't be pinned down to a single spot or their message understood; perhaps these are remnants of some long-forgotten conversation replaying itself through time.

Mists have been seen around the artillery emplacements on the University of Mississippi Medical Center campus, as well as along Fortification Street. Unexplained balls of light that seem to flit aimlessly about have also been seen.

The Old Capitol building, which is now a museum, supposedly has cold spots that occur in various locations, most notably in an upstairs office. The story goes that in the late 1800s, a legislator was working late in his office when he suffered a fatal heart attack, slumped across his desk and then slid to the floor with a thud. According to the legend, every day at 5:15 p.m., a thud can be heard coming from that office, even though no one is on that floor. Doors are reported to open and close by themselves, and objects suddenly fall to the floor when no one is near them.

The ghost of a woman reportedly runs out into the roadway on Terry Road before disappearing, and the specter of another woman in what has been described as late 1800s clothing has been seen in the very early hours of the morning wandering down South State Street, only to smile sweetly and then disappear when approached.

Jackson is a nice city to visit, with plenty to see and do, and parks, museums and historical sites abound, giving the visitor and resident alike plenty to occupy their time. It would appear that it appeals to the dead just as much as the living.

Ridgeland

Ridgeland has an old history, although it wasn't until 1970 that it was actually incorporated as a city. In 1805, the area where Ridgeland is located was known as the Choctaw Indian Agency and was overseen by a man named Silas Dinsmore. At that time, it served as a stand along the Natchez Trace and was then called Turner Brashear's Stand until around 1850, when it was converted into a hotel known as King's Inn. King's Inn would continue to serve travelers until it was destroyed by fire in 1896.

In 1853, James B. Yellowly founded a community in the area called Yellowly's Crossing, although he later changed the name to Jessamine in honor of his wife, and it was eventually sold to two real estate developers from Chicago who laid out the plans for what would become Ridgeland. They advertised for people from the North to move south, and their advertising campaign stressed the moderate climate and fertile ground and was, by all accounts, quite successful, as by 1899 Ridgeland was incorporated as a village.

The Jessamine Cemetery, maintained by the City of Ridgeland, is the oldest cemetery in the city and holds the remains of some of the earliest settlers of Ridgeland, including James B. Yellowly. Though there are other cemeteries in the area, the historical part of Jessamine seems to be where all of the paranormal activity is centered. Lights are seen moving about the graves at night although no one is ever seen when they are investigated. Mists are seen to rise from the graves, hover a few feet off the ground and then disappear. A young lady, dressed in a white gown of some type, is seen walking among the tombstones, as is an older gentleman who seems to be a bit agitated. Both disappear quite quickly when noticed and approached. A young boy is seen running from the main entrance to the cemetery, and he has been seen both at night and in the daytime hours, disappearing just a few short feet from the arched entrance sign. Those who have seen him thought that he was running away from something, although nothing else has ever been seen.

MADISON AND THE CHAPEL OF THE CROSS

The city of Madison began life late compared to other cities along the Trace, coming into existence in 1856 as a station along the Illinois Central Railroad called Madison Station. It was mostly destroyed in 1863 in the Union push to capture Jackson but recovered and was rebuilt due in part to the railroad. The most interesting tale about Madison stems from a certain area that was once the community of Mannsdale but now resides within the confines of present-day Madison.

John Johnstone moved into the area with his two brothers, Samuel and William, and he began farming on about 2,600 acres of land. The plantation was prosperous by all accounts, and eventually two plantation homes were built on the property, one named Ingleside, which was a gift to John's oldest daughter and her husband, and the other called Annandale,

completed for his widow and their youngest daughter, Helen, several years after his death.

John's widow, Margaret, began construction on a chapel where both the family and slaves could worship, honoring a desire that John had to build just such a structure, though he unfortunately did not live long enough to build it. Bricks were made in a kiln close by, and with mostly slave labor and $3,000, Margaret brought the chapel into existence around 1852. The chapel was used for a time before it fell into disuse, then it was put into service once more through the years and finally restored to its original form in the early 1970s, when it was placed on the National Register of Historic Places.

Several stories are associated with the Johnstones, Annandale and the Chapel of the Cross. The first is that of Annie Devlin, a former governess in the employ of the Johnstones, who met with an untimely demise in June 1860. She was reported to have haunted the structure until it burned to the ground in 1924. Sightings of her continued on the grounds for years after

The Chapel of the Cross in Madison was built around 1852 and is the site of the ghost story about the "Bride of Annandale," otherwise known as Helen Johnstone, who buried her fiancé, Henry Grey Vick, on the day that they were to be married. She is said to weep beside his grave to this day. This photo was taken in 1934 as part of the Historic American Buildings Survey. *Courtesy of the Library of Congress.*

the plantation home burned, with some stating that she seemed to be in a state of distress, thought to be caused by the burning of Annandale.

The Chapel of the Cross has several legends associated with it, one a story of love tragically lost, and the other of murder. A caretaker of the church reportedly murdered his mentally impaired wife in a fit of rage while in the church, beheading the poor woman. He cleaned up the blood as best he could from the stone floor before finally hanging himself from the church rafters. It's said that the bloodstains from the murdered woman will appear at times on the stone floor before disappearing. Giggling and organ music are also reported coming from the church after it has been closed and locked up for the night.

The most famous story and the one most reported as being experienced is that of Helen Johnstone's ghost, or as some have come to call her, the "Bride of Annandale." Helen was the youngest daughter of John and Margaret Johnstone and by all accounts was quite beautiful. She fell in love with Henry Grey Vick, son of the founder of Vicksburg, having met him at her sister's home in December 1855, and later, much to the delight of both families, they were engaged to be married. With the wedding day set for May 21, 1859, preparations were made for an elegant ceremony at the Chapel of the Cross. Unfortunately, Henry embarked to Mobile, Alabama, on business, assuring Helen that he would be back in plenty of time for their wedding. There he got into a duel and was killed on May 17, 1859, a short four days before the wedding. His body was brought back to Annandale, where Helen led a torch-lit procession from Annandale to the cemetery behind the Chapel of the Cross to bury her fiancé on the very day that she was to be wed. To say that she was shocked and crushed would be an understatement, and some say that she never quite recovered from it, even though she would go on to marry another. It is her ghost that is believed to be the woman weeping at the grave of Henry Grey Vick, having been witnessed by dozens of people. She is said to be seen silently weeping at night, agonizing over her lost love, and reportedly vanishes whenever approached. The church now locks the cemetery gates at 5:00 p.m. each night to give poor Helen her privacy and the chance to grieve in peace.

JACKSON NORTH TO THE ALABAMA STATE LINE

We will continue our trip up the haunted Natchez Trace from just north of Jackson following along the Ross Barnett Reservoir, passing by Kosciusko and French Camp, past the Witch Dance and on past Tupelo to the state line. Once past Jackson, traffic tends to dwindle, and you find yourself cruising along at fifty miles per hour enjoying the solitude, broken only by the occasional passing vehicle. As you travel farther north, the terrain starts to get a bit more rolling, and trees thickly line the roadway, further increasing the feeling of solitude and remoteness. Our first stop is Canton, less than ten miles off the Trace on Mississippi Highway 43.

CANTON

Canton is a very beautiful city located in Madison County, Mississippi, just off the Natchez Trace, its residents friendly and welcoming to visitors. Legally incorporated in 1836, the town prospered and grew to support a population of approximately 2,000 citizens in 1861. The town's growth was largely due to its being the terminus of two railroads: the Mississippi Central Railroad and the New Orleans, Great Northern and Jackson Railroad. The town boasted many hotels to accommodate travelers and at one time had over thirty saloons to help entertain those staying in Canton. Today, much of Canton is listed on the National Register of Historic Places, with the courthouse square designated as a historic shopping district and home to the

famous biannual Canton Flea Market Arts and Crafts Show, which attracts more than 100,000 visitors each year. The historic courthouse was built in 1855, with the local Masonic Lodge laying the cornerstone in a ceremony held in July. Through the years, the courthouse has been witness to much history, seeing the Civil War turn Canton into a Confederate hospital area, serving as a hospital itself during the yellow fever epidemic and even serving its community as a library and theater.

During the period of Reconstruction immediately after the Civil War, tensions were so high during an election due to allegations of ballot box stuffing that violence threatened to break out. A group of officials climbed into the dome of the courthouse and dispersed the agitated crowd by pelting them with rocks from slingshots, effectively curtailing any outbreak of bloodshed. Between 1994 and 1995, a new courthouse was built a block north of the historic one, and the original underwent a $2 million renovation that saw the 1855 cornerstone opened and re-laid once again in a ceremony by the local Masonic Lodge.

It is estimated that nearly $20 million in private and public funding has been poured into the courthouse square and historic districts, preserving the beauty and uniqueness of the area. Even Hollywood has taken notice of the historic value with a reported five major films being shot there, including filming for a movie adaptation of John Grisham's novel *A Time to Kill*.

While Canton was never the site of any major Civil War battles, the city has seen its share of suffering and death. With its railroad lines and strong Confederate state patriotism, Canton supplied the Confederacy with several units of riflemen and an artillery unit known as the Madison Light Artillery. By 1862, Canton was the site of a Confederate hospital, which was being operated out of the building that was the local Masonic temple and was first opened to handle the overflow of casualties from the first Battle of Shiloh and the evacuation of Corinth in April 1862. The next wave of wounded would come in October 1862 following the second Battle of Corinth. Wounded were loaded on boxcars and moved south along the rail lines, with some being dropped off in smaller towns along the way for treatment in civilian homes. Some would perish from their wounds during transport, and still others would die shortly after reaching Canton. The hospital, known as the Semmes Hospital, would operate until around July 1863, when the Siege of Jackson would force the evacuation of the wounded. At times, there were so many casualties in Canton that an additional five or six other buildings were pressed into service to help shelter the wounded. With that many wounded, it is little wonder that the Confederate portion of the Canton City Cemetery

holds the remains of 350 Confederate soldiers who succumbed to their wounds while being treated in Canton.

An epidemic of yellow fever caused the deaths of a number of Canton residents, among them Dr. James Priestley, who was the local doctor and first postmaster of the city. He built a fine home in 1852, known now as the Priestley House, and set up housekeeping with his wife, Susan. It's not clear whether he died in his home from the outbreak of yellow fever or at one of the hospitals set up to care for the sick, but his wife died in her bedroom in the Priestley House, and it is her spirit that is thought to haunt the home. Several people have seen her spirit in her bedroom, and people passing by who happen to look up have also noticed her standing in the window. The piano has been heard to play by itself, and candles have been reported to fall from both their holders and from the tables on which they sit. It is believed that Susan loved her home so much in life that she didn't want to leave it in death.

Sightings of Confederate soldiers in and around the cemetery are common, as are the reported sightings of soldiers near where the old Semmes Hospital was located. Mostly they are just glimpsed and then gone, making the witness wonder if they had ever actually seen them. The usual mists and balls of light have been seen in the Canton City Cemetery, home to almost three thousand souls, some having been buried there as early as the 1850s. The figure of a lady dressed in black has been seen both sitting and kneeling beside a grave and is said to look up with tears in her eyes when approached before quickly fading from sight. Those who have seen her have thought that they were witnessing a live woman grieving at a grave site and have walked over to offer comfort and assistance only to have her disappear before their eyes.

The ghost of a black man has been seen walking along Highway 43 in the early morning hours and is said to wave as you pass by before disappearing. He is dressed in clothing reminiscent of the 1950s, and a person would have to wonder if he might not be the spirit of Sylvester Maxwell, whose mutilated and castrated body was found in Canton on January 17, 1963, a victim of racial violence whose murder is yet unsolved. If it is indeed the spirit of Mr. Maxwell, perhaps he remains in Canton waiting for the time when his murder is solved and justice is served.

Despite the death that Canton has witnessed over the years, all of the ghost stories and legends seem to be peaceful in nature; the ghosts are seemingly content with their occupation of the town. Perhaps they feel the same welcoming vibe from the residents that visitors to the city also feel.

The Cypress Swamp

Located at milepost 122 is a small parking lot that marks the entrance to the cypress swamps. Part of an abandoned river channel, it is filled with water tupelo and bald cypress trees, the water black and reflective like a mirror. A few feet up from the water, red maple, sycamore and other species of trees and vegetation form the surrounding forest, adding to the canopy of branches and leaves that help to break up and filter the sunlight.

Wildlife is plentiful here, with your average assortment of squirrels and other woodland creatures, but it is the black water that holds the real reason these swamps and others like them were a convenient place to dispose of bodies: alligators. The swamp is home to alligators, and they can be seen frequently, lying still in the water looking for all the world like rotting logs with nostrils.

A half-mile trail circles part of the swamp; a wooden footbridge spanning the dark waters merges with the trail that hugs the shoreline of the swamp, making a twisted, crooked circuit starting from the parking lot and ending up at the same. On the backside of the trail, it is relatively easy to imagine how the Kaintucks and other travelers felt when they faced traversing the swamp. The quiet woodlands; dark, still waters; and shaded, uneven light create a solitude that can, at times, make you feel a bit disconnected, ill at ease and a trifle uncomfortable. The thought of gators lurking in the black water doesn't help either.

Land pirates such as John Murrel and Joseph Thompson Hare frequented this area, stealing, robbing and murdering when a favorable chance presented itself. Over the years, legend says that human bones have been discovered in the swamp area from time to time when the waters recede during the hot, dry summer months. Most were thought to be very old and perhaps were all that remained of some unlucky Native American or traveler of the Old Trace. It would have been just a short mile of easy travel from the Old Trace to the cypress swamps, making it relatively easy for a highwayman to dispose of his victim there.

Stories have been told at times of the sighting of a bearded man in what has been described as homemade or homespun clothing standing at the edge of the parking area. He is said to stare blankly ahead even though the lights of the vehicle entering the parking lot should have blinded him or at least caused him to flinch and turn his head away. He reportedly continues to stand there staring for a moment and then turns slowly toward the dark water of the swamp and fades away.

If you stop at the cypress swamp in the evening, take a walk out onto the wooden footbridge and stop for a moment. People have reported hearing the sounds of an argument followed by what sounds as if someone is being beaten coming from the woods just off to the east of where the bridge ends. The sounds have been investigated several times, but no source has ever been discovered, and each time someone has checked it out, the batteries in his or her flashlight have mysteriously drained just a few seconds after stepping off the bridge. If you happen to hear it and are brave enough to go investigate, make sure you have extra flashlight batteries and watch out for gators.

This photo of the Cypress Swamp next to the Natchez Trace was taken around 1937. *Courtesy of the Library of Congress.*

Photo of the Cypress Swamp as it looked in November 2011. *Photo by Bud Steed.*

KOSCIUSKO

At milepost 160, just a bit west of the Trace, sits the city of Kosciusko. It was named for the Polish general Tadeusz Kosciuszko (the "z" was dropped from the name by accident), who served with the colonials during the Revolutionary War. Originally, though, it started out under the name of Red Bud Springs, named after one of the three natural springs that were located there. The name would later be changed from Red Bud Springs to Prentiss and was then once again changed to Parish before obtaining its present-day name. It's been said that when it was named Parish, people referred to and spelled it as "Perish" due to the dangerous activities of the area, credited largely to John Murrel and his gang operating there.

Kosciusko, pronounced by the locals as Kah-zee-Ess-ko, has maintained a fairly steady growth since its inception, due in part to the fertile farmland surrounding the city and its place on the Aberdeen Branch of the Illinois Central Railroad. It became the county seat of Attala County, and though one would have thought that its status as such, along with its place on the railroad, would have ensured that the fighting of the Civil War would have found its way there, such was not the case. Even though the sound of cannon fire could be heard in the distance, not a single shot was fired in the town. It seems to have always maintained its sleepy southern charm without any major violent incidents to mar its name.

The town is noted as being the birthplace of talk show host Oprah Winfrey, who grew up there until the age of six. Buffalo Road was later renamed Oprah Winfrey Road in her honor and runs past her church and birthplace.

The Kosciusko City Cemetery is quite large and quite old with some of the first burials dating back to the early 1830s. One unusual story about this cemetery is the sighting of a dog that seems to be haunting it. It is not your usual huge black dog with fiery red eyes blazing in the night that chases poor wanders like a hellhound bent on consuming a soul; no, this dog is described as a small beagle that, most times, just seems to be lying quietly beside a grave, though not always the same grave, only to fade away upon approach. Other times, he has been glimpsed running through the cemetery with his nose to the ground, passing directly through headstones and then suddenly disappearing. To whom he belonged or why he has chosen to make the cemetery his home is unknown, but perhaps he was someone's beloved hunting dog and companion that simply couldn't bear to leave his master.

Another unusual story is that of the Laura Kelly grave, also in the City Cemetery. Laura V. Mitchell Kelly was born in 1852 and died in 1890 at the young age of thirty-eight. She suffered a bit of loss and tragedy in her short life that may explain part of the legend surrounding her grave. She was married to C. Clay Kelly, who was a successful businessman in Kosciusko, and together they had four children. Of those children, one would die at the age of one and another at fourteen, both preceding their mother in death. The remaining children would live short lives as well, one passing away at age twenty-two and the other at age thirty-five. When Laura passed away, her husband was understandably distraught and ordered a statue said to be carved in her likeness, wearing her wedding gown, from a sculptor in Italy. As their new home on East Jefferson Street was also in the process of being built at the time of her death, Mr. Kelly instructed the builder to add a third floor to the structure so that he might sit and view the monument to his wife from the window.

The monument is a beautifully crafted sculpture, and it is around this sculpture that two stories have sprung up. One states that upon the anniversary dates of the deaths of each of her children, the statue begins to weep silent tears that stream slowly down her marble cheeks to disappear before they hit the ground. The other story states that on the anniversary date of her marriage to C. Clay Kelly, a fresh rose appears in her cupped hand—perhaps a loving gesture from beyond the grave by a man who loved his wife so much that he immortalized her image in stone.

French Camp

French Camp, Mississippi, sits alongside the Natchez Trace Parkway at milepost 180.7 and has a paved parking area right on the Trace next to the historical area. First established in 1810 by Louis LeFleur, a French trader and explorer, as a tavern on the then halfway point of the Trace, it served travelers along the road for many years. LeFleur had previously founded the settlement of LeFleur's Bluff on the Pearl River in 1800, a settlement that would later go on to become the city of Jackson.

Louis LeFleur would marry a part-Choctaw woman named Rebecca, who was the daughter of a Frenchman named Cravat and his Choctaw bride, a sister of the famous Choctaw chief Pushmataha in Mobile, and from that union Rebecca and Louis had a son who was named Greenwood.

Greenwood would receive an education in Nashville and, upon returning to French Camp with his bride, would eventually be elected chief of the Choctaw Nation in 1824. His council house, where he met with other members of the Choctaw Nation, is now home to the Council House Restaurant. Greenwood encouraged his tribe members to become landholders, knowing that their future depended on their coexistence with the white settlers who were moving into their lands. He would later become a Mississippi state senator, and he traveled several times to Washington, D.C., to meet with the president to confer over matters regarding the Choctaw. His restored carriage, which carried him over the Natchez Trace on those trips, is on display at French Camp.

In 1822, Presbyterian missionaries established a school in French Camp. The school, along with French Camp, continued to grow and thrive, and in 1855, the school facilities were enlarged by the Presbyterian Synod to include a boys' military academy and a girls' boarding school. French Camp escaped the ravages of the Civil War since it had become mainly a cultural center for the county, but its immediate neighbor eleven miles to the northeast, the city of Bankston, was an industrial center and suffered great damage during the war. Still, as late as 1877, French Camp was considered to be the largest town in the county and continued to thrive. The school, known today as the French Camp Academy, is still in operation and functions as a private Christian boarding school helping children who are facing difficult times in their lives. The nine-hundred-acre school is a community within a community, with over three hundred students and adults living, learning and working at the academy.

One of the buildings in the historic area is the Colonel James Drane house, built in 1846 using a water-powered saw to cut the timber for its construction. Wooden pegs were used to secure the frame and foundation, and the ceiling and upper portions of the structure were secured with squared nails. The Huffman log cabin, built in 1840, stands nearby and is in use as a gift shop. A log cabin museum and several log outbuildings, including a blacksmith shop, round out most of the historic district.

The cemetery sits just west of the Trace and contains the graves of some of the oldest settlers of the area, but it is not the only place in French Camp where bodies are buried. One historical record stated that General Jackson's men, upon their march back northward from the Battle of New Orleans, stopped at French Camp to rest and recuperate. Louis LeFleur had served with Chief Pushmataha during some of the battles of the War of 1812, so he and Jackson were known to each other by more than just reputation. By

The Drane House, built by Colonel James Drane in 1846. It is now part of the historical site at French Camp. *Photo by Bud Steed.*

Historic outbuildings at French Camp, Mississippi. French Camp was founded by explorer and trader Louis LeFleur in 1810. *Photo by Bud Steed.*

accounts, the army was camped in the glade in the center of town, and some of the men who died from sickness or their wounds were buried in unmarked graves on the outskirts of the glade. That could possibly account for the few sightings over the years of what have been described as frontiersmen

seen standing near trees in town, suddenly disappearing in an instant when noticed. Spirits that also appeared to be from the early 1800s have been seen in the evening and early morning hours moving about the log outbuildings. The Drane House is also the site of paranormal activity, with items being moved from one spot to another during the night and voices and laughter heard coming from the house after it has been secured for the night. The cemetery is home to reported mists and balls of light that dart about when darkness settles over the area. Voices have been heard in the cemetery carrying on quite a lively discussion, though no one can be seen. Stories like these are common in areas such as this that have experienced much history, where the struggles of life leave their imprint on the land.

French Camp is a great spot to stop and visit, have a meal or stay at the bed-and-breakfast, and should you rise early from your bed, just as the land is starting to lighten, take a look out your window: you just might see a frontiersman standing watch near the trees.

WITCH DANCE

Located at milepost 233.2 on the Natchez Trace is one of the most unusually named areas on the entire road: the Witch Dance. At the edge of the Tombigbee National Forest, tall trees and forest growth surround open areas of natural grasses and vegetation, interlaced with several horseback and walking trails that weave through the woods.

Its name, Witch Dance, is an old one, originating with some of the earliest travelers of the Trace, when the road was nothing more than a path through the forest. Legend says that a coven of witches gathered at the site to perform ceremonies and that as they danced around, wherever their feet touched the ground, the grass would wither and die, never to grow again.

Andrew Jackson, who traveled the Trace many times, made mention of the curious bare spots in his journal, and it is said that "Big" Harpe, the notorious murderer and thief, scoffed at the legend. When told the story, he reportedly openly sneered at the legend and proceeded to dance about leaping from bare spot to bare spot, daring the witches to come out and kill him. He obviously considered himself far more dangerous than any witch.

The bare spots are still there today, as clearly visible as they have ever been. The parking lot for Witch Dance is quite large, with restroom facilities and picnic areas, but the park service has seen fit to not include any signs

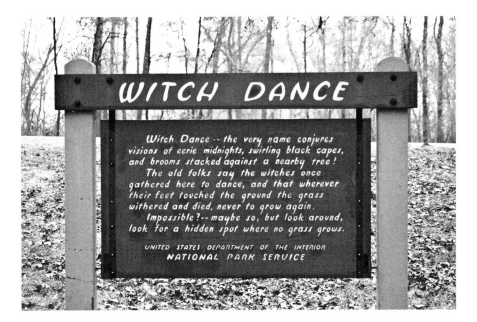

Sign detailing the legend of Witch Dance near the site on the Natchez Trace. *Photo by Jennifer Steed.*

marking the bare spots or pointing the way toward them; you must do a little searching to determine where they are, though once located, they are easily recognizable.

The legend of the Witch Dance area doesn't stop at just bare spots on the ground. Stories have been told of people in both the picnic areas and walking down the horseback trails who have been touched, and even pushed, by unseen hands. Muffled voices are heard coming from the trees, and what has been called the "maniacal laughter" of more than one voice has been heard coming from the woods near the picnic areas.

One hiker, a college student from up north, had accompanied a friend from the University of Mississippi to his home in Tupelo to spend a few days relaxing and getting ready for the upcoming finals. He was out taking an early morning stroll down one of the horseback trails, enjoying the early morning quiet and solitude, when he found himself the obvious target of some unseen entity's torment. As the story goes, the young man was strolling along enjoying the morning and reciting portions of his history studies in preparation for an upcoming test when he suddenly tripped, sprawling face first into the dirt. Getting up and brushing himself off, he simply shrugged

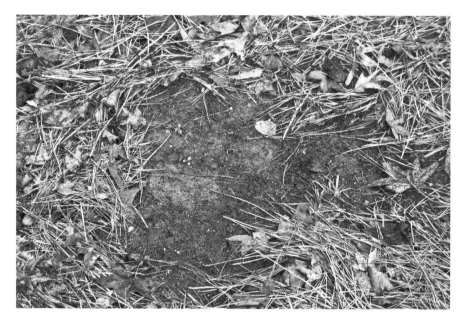

Some of the bare spots where grass will not grow, said to be caused by witches dancing at a gathering. It is said that anywhere their feet touched the ground, the grass withered, died and never grew again. *Photo by Bud Steed.*

it off as clumsiness and lack of attention and went on his way, a little more cautiously this time. A short ways down the trail, it happened once again, though this time he could clearly feel something tangling up around his feet. When he got up from the ground, he looked all around but could not find anything that could have tangled up his feet and caused him to fall. Obviously more alarmed and a bit shaken, he nevertheless continued on with his walk, scanning the ground intently for anything that might trip him up. Nothing happened for a few minutes, and he relaxed a little, though still remaining vigilant of the trail before him. After about two hundred yards of travel, he suddenly heard whistling coming from the tree line, the sound one would make when absentmindedly whistling while performing some task. He searched the tree line for signs of anyone and even called out, but he could see no one, nor did the whistling subside. Starting to get a bit concerned, he decided to turn around and head back for the parking area, which by now was a good mile and a half away. As he walked, he could hear the whistling getting louder and louder, closer and closer, though he could still not see anyone. Admittedly, he was starting to get a little bit spooked and started to pick up the pace, wanting to get back to the safety of his car as

quickly as he could. The whistling continued on, and suddenly he was struck by a rock that seemed to come literally out of nowhere, striking him squarely in the back. Definitely scared now, he abandoned the idea of walking for the alternative of running, and he set off at a quick pace down the trail, still followed by the whistling, broken now and then by hearty laughter followed by another thrown rock or two. The rocks, laughter and whistling followed the unfortunate young man all the way back to the parking area and only subsided when he ran straight from the trail and through the parking lot, jumped into his car and locked the doors. He sat there for a moment trying to regain his composure when a rock bounced off the side of his car, and he clearly heard a loud voice, which seemed to be speaking directly into his right ear, tell him, "Get the hell out of here and don't bring your Yankee ass back again." Needless to say, the young man, scared out of his wits, tore out of the parking lot and raced back to his friend's home, where he related his experience. His friend scoffed at the thought of ghosts and suggested that they go back out and see if they could find the source of the rocks, but the young man was still too badly shaken up and vowed to never again set foot at the Witch Dance.

Apparently, there is something besides witches at Witch Dance, and they seem to be not overly fond of Yankee college students, so if you decide to hike the horseback trails of the Witch Dance, I might presume to offer this advice: speak in your best southern drawl and try whistling Dixie as you walk; you just might be considered a friend rather than a foe and escape the barrage of rocks.

Tupelo and the Tupelo National Battlefield

There are five exits for Tupelo off the Natchez Trace, but the one I find myself using the most when I travel on the Trace is at milepost 260. Mississippi Highway 6 turns into Main Street and takes you past the Tupelo National Battlefield marker, as well as past numerous shops, restaurants and hotels. Following this through town will take you to Highway 45, where heading north will take you to Highway 78 and the Barnes Crossing Mall, another grouping of shops, eateries and motels.

Settlement in the Tupelo area is old, with the Chickasaw Indians having a large settlement there at the time of Hernando de Soto's trek through the area in 1540. They were fierce fighters who are credited with driving him westward from their lands toward his discovery of the Mississippi River. In

1736, the Battle of Ackia saw British armed and backed Chickasaws defeat a French- and Choctaw-led force, giving the British a firm hold in the area and aiding in their ultimate control of most of North America.

From the earliest times of settlement, the Tupelo area was linked to both the north and the south by the Natchez Trace, which was the main trade route for the residents of the area, both Indian and white. The town was originally named Gum Pond by early settlers, due to the large numbers of tupelo trees, which were also known as black gum. Supposedly, the southern expression "possum up a gum tree" originated from the Tupelo area, and each year the city hosts an annual event called the Gumtree Arts Festival.

The area saw several Civil War battles, such as Brices Cross Roads and the Battle of Tupelo, the latter taking its name from the tupelo trees. On July 14–15, 1864, the Union army under the command of Major General A.J. Smith engaged the Confederate cavalry forces of Major General Nathan Bedford Forrest and his commanding officer, General Stephen D. Lee, in an attempt to keep the railroad lines secure, enabling supplies to reach General Sherman.

On July 5, 1864, Sherman had ordered General Smith to take his 14,000 men and move south from LaGrange, Tennessee. His reasoning was that General Forrest had defeated the Union forces earlier at Brices Cross Roads, and Sherman was afraid that Forrest might start moving his forces into Tennessee in an attempt to destroy the railroad and cut off the much-needed supplies that Sherman would require in his push through Georgia. General Smith moved south, destroying much of everything in his path until he finally came to Pontotoc, Mississippi, on July 11. General Forrest was at that time in nearby Okolona with approximately 6,000 men and wanted to attack Smith immediately. His commanding officer, General Stephen D. Lee, refused to allow him to attack until he had been reinforced with additional troops. In the meantime, two days later, General Smith, who feared an ambush might come, decided to move his force east toward Tupelo, and once there he proceeded to dig in and prepare for the coming attack. General Lee joined Forrest with an additional 2,000 men, and an order for attack was given on the night of the thirteenth. The Confederates attacked at 7:30 a.m. the next morning in a series of vicious but uncoordinated attacks that the Union army beat back, though not without heavy casualties on both sides, including Forrest himself, who was wounded during one of the assaults. They fought for most of two days with a casualty list of 1,948 soldiers, of which 1,300 were Confederates.

After the Confederates withdrew, General Smith, who was short on rations and believed his army to be in a precarious situation, marched back to Memphis, Tennessee. He had been successful in his attempt to keep Forrest and the Confederates busy and away from the railroad, and he was also successful in protecting Sherman's supply lines.

The battlefield today lies within the city of Tupelo, and not much of it remains. There is only about an acre of ground maintained by the National Park Service in the spot where the Confederate forces hit the main Union defensive positions. A commemorative monument and a couple of cannons, along with a few interpretive panels detailing the battle, are all that is contained at the site. The rest of the battlefield has fallen victim over time to the push of progress; most of the battlefield itself is now covered in commercial buildings and residential neighborhoods, lost forever.

The city itself continued to grow and officially became a city in 1870, taking its name from the native gum tree. By 1887, two railroads ran into Tupelo: the Mobile and Ohio Railroad and the Kansas City, Memphis and Birmingham Line. The town grew steadily after becoming a manufacturing and rail distribution center, and it continues to thrive and grow today, with many manufacturing facilities and distribution centers located there.

The city has several claims to fame, the most advertised and well known being that Elvis Presley was born there on January 8, 1935. The small shotgun-style home, built by Elvis's father in anticipation of the upcoming birth, still stands today. The remodeled home, along with the Elvis Presley Museum and memorial chapel, draws over 100,000 tourists to Tupelo each year, making it the hallmark of Tupelo's $46 million dollar tourism industry.

In 1932, famous gangster Machine Gun Kelly committed his last known bank robbery in Tupelo, relieving the Citizens State Bank of $38,000 before making his getaway. In 1934, Tupelo made history as the first city in the nation to provide its citizens with affordable electric service, made possible by the power plant at the Tennessee Valley Authority.

In April 1936, tragedy struck the city as an EF5-rated tornado ripped through the town at night, destroying entire neighborhoods on the city's north side. The official death count was set at 216, but the actual count will never be known as African Americans were not counted. The neighborhood of Gum Pond was completely destroyed, and most of the victims' bodies were thrown into the pond by the tornado. The book *Tupelo, Mississippi, Tornado of 1936*, by historian Martis D. Ramage Jr., tells the story of that night and includes many rare photographs of the devastation. Tupelo continues to grow and thrive, its citizens are friendly and helpful and overall it is a very

nice place to visit or reside—so nice, in fact, that some people prefer to stay even after they have passed on.

The Lyric Theatre, built in 1912 by R.F. Goodlett, started its life as the Comos and was originally a vaudeville theater showing live performances for many years. In the 1930s, it was purchased by the M.A. Lightman Company, which ran a chain of movie houses under the Malco brand. Its solid brick construction made it one of the few structures to withstand the tornado of 1936, and it was pressed into service as a temporary hospital and mortuary. It's been said that the popcorn poppers were even used to sterilize the surgical equipment between emergency operations. It's from this temporary incarnation as a hospital and mortuary that some of the legends of hauntings have stemmed. Doors slamming, cold spots that seem

The Lyric Theatre in Tupelo was used as a hospital after the devastating tornado of 1936 that killed over one hundred people. *Photo by Bud Steed.*

to follow you wherever you go and the popcorn poppers suddenly turning on by themselves are well-known stories. Those working late at the theater, especially in the late evening and early morning hours when all is quiet, report that the sounds of people in agony have been heard in the stillness. The sound of what has been described as metal striking metal, as in a surgical instrument being dropped into a metal pan, has been heard coming from near the concession area, perhaps a leftover memento of the instrument sterilization that occurred there. The Lyric Theatre today is home to the Tupelo Community Theatre, which once more holds live performances there. The theater has undergone extensive remodeling since the Tupelo Community Theatre acquired the property in 1984, with the community and supporters donating over $2 million for its restoration.

The Movies 8 Theatre, in the Barnes Crossing Mall, is said to be haunted by several spirits, including a girl named Lola. *Photo by Bud Steed.*

Spirits in Tupelo seem to have a penchant for theaters as the Lyric is not the only known haunted theater in the city. Though it seems an unlikely place to be haunted, nonetheless it has been reported by many that the Movies 8 Theatre at the Barnes Crossing Mall has some spirits of its own. No one seems to be aware of any tragedy or deaths at the theater that might be the basis for the haunting, but many people have experience the ghosts that are reported to make the theater their home. The best known of the spirits is Lola, though no one seems to know if that is really her name. She has been described as a pretty young girl who seems to be quite friendly, if not a bit mischievous. She has been seen in multiple locations within the theater, including the employee break room, where she was seen walking around a table and lifting the lid off of the trash can in the corner of the room to peer inside it. She has been seen and heard in the back room of the concession area, moving things around and making loud noises, as well as in the arcade area. She is credited with moving money

around in the cash registers and with opening the doors on the popcorn poppers. Another ghost said to haunt the Movies 8 Theatre is that of a man who hangs out upstairs in the projection room. He likes to follow people around upstairs and has even been known to accompany people to the concession storage area. Seats have also been reported to suddenly fold down before a movie starts as if someone has come in and sat down. Both of the ghosts seem to be quite friendly and peaceful, with no reports of any physical violence or intimidation from either of them. They both just seem to like movies.

The area of the Tupelo National Battlefield has had its share of ghostly soldier reports, though curiously, none seems to have been reported on the remaining one-acre plot where the monument and cannons are located. Most seem to stem from the residential neighborhoods and from the streets surrounding the memorial site. Soldiers have been seen moving quickly toward the monument area, as if running forward in attack, only to disappear after a few feet. They are charging forward one minute and fading away the next. A home situated on Hancock Street, just south of the memorial site, and another on Government Street have each been the scene of several sightings as well. In one report, the family was sitting in the living room of their Hancock Street home watching TV one night, all of them snuggled up together on the couch, when they became aware of someone standing in the corner of the room off to the right of the couch. The husband automatically went into fight mode, thinking someone had broken into the home and his family was in danger, and he leaped up from the couch, placing himself between his family and the intruder. He challenged the person, ordering him to leave his house, and much to everyone's surprise, out from the shadows stepped a Confederate soldier in uniform, complete with rifle. He reportedly stepped forward and paused for a moment, staring at the man and his family, bowed slightly and then just simply faded from sight. The clearly shaken parents snatched up their children and fled the home, staying the night at a relative's house. The man went home the next morning after it became light and, with the accompanying relative, searched the house for any signs of the soldier. Since that time, he has not been seen again, although cold spots have been felt and things have disappeared only to turn up several days later in a spot that had already been searched. The family seems at peace with the presence, stating that after they calmed down from the initial shock, they realized that there had never been a threatening feeling coming from the soldier but rather one of extreme loneliness.

The home on Government Street also experienced a soldier, but this one was not so chivalrous and accommodating in his actions. The husband and wife were sleeping one night when the husband felt a sharp blow in his side. Thinking that his wife had elbowed him in her sleep, he started to turn over before realizing that his wife was sleeping on the opposite side of the bed. Clearly puzzled, he sat up in bed and, swinging his feet to the floor and standing up, came nose to nose with a man who had been standing there. The homeowner, who readily admits that his reaction was purely instinct, immediately lashed out to push the intruder away, but his hands went completely through his opponent, and, off balance, he tumbled forward to the floor. Quickly rolling over, he looked up to see what he would later describe as a Confederate soldier bending over him with a menacing look on his face. About that time, his wife woke up and let out a shriek loud enough to wake the dead or, in this case, a Confederate soldier, who wheeled around and looked at the wife, who in turn immediately fainted. The husband states that the soldier let out a hollow-sounding laugh, walked completely through the bed, the wife and the wall and then exited the home. Needless to say, the couple was shaken up, and like their neighbors, they departed from the house for the night. Several more times they both saw the soldier, but after the initial confrontation, he only seemed interested in watching them, and they reported cold spots following them all around the home. After a month of this steady intrusion, with the soldier refusing to leave even though both the husband and the wife had requested him to do so on multiple occasions, both agreed that it was time to sell the house and move on because they were unable to deal with the lurking soldier who made his presence known every day and at all hours.

Other sightings have been reported of soldiers walking through backyards, of hearing voices and shouts and even of the sound of gunfire accompanied by the smell of gunpowder. Mists form and disappear at odd times, never lasting long at all, and the often-reported balls of light have been seen near the park.

The Thirteen Unknown Confederate Soldiers' Grave Sites

Just off the Trace at milepost 269.4 and along a section of the preserved Old Trace lie the graves of thirteen unknown Confederate soldiers. Just who they were, where they came from and how they died have been lost to time. The sign near the graves states that their names might have been on

the original markers that disappeared a long time ago. Senator Theodore Bilbo, in 1940, arranged for marble headstones to be placed at each grave in memoriam, but not long after placement they were stolen by some low life(s). The headstones that you see in the photos were later placed by the National Park Service, and the flowers and flags were left by a kindly unknown source.

The sign at the entrance to their little row of graves speculates that they could have been some of the wounded from Shiloh who died passing this way in 1862 or perhaps members of General Nathan Bedford Forrest's command who died in an unknown skirmish. Either or none of these assumptions could be correct, and we will sadly never know the story behind these thirteen unknown graves. Their headstones face backward toward the Old Trace so that any who should pass by might read them and give silent recognition to the sacrifices of these thirteen souls. People have often wondered why they were buried behind their tombstones, some speculating that they were deserters and were buried as such out of disrespect, but that is simply not true. In Christian belief, to which these soldiers and their compatriots most likely subscribed, bodies were buried with the head at the west end and the feet at the east end of the grave. Tradition states that Jesus, upon his return, would come from the east, and the bodies placed as such would be able to see the coming of the Lord at Judgment Day. The only level area suitable for burial in that spot was on the east side of the Trace, where the graves are located, the headstones turned backward to face the road.

My wife and I stopped by these lonely graves in November 2011 to pay our respects to these fallen soldiers, and I was slightly taken aback by the disrespect some people show for the site. Flowers and flags were knocked over, and cigarette butts lay all around the graves and the entrance. I picked up what cigarette butts I could find while my wife straightened the flowers and flags beside each headstone, breaking out into silent tears while she did so. When I asked her what was wrong, I received her standard answer of "I don't know," followed a moment later by, "It's just so sad." While we were doing this, another pair of travelers stopped by, looked at us and quickly left, as if afraid we might ask them to help. It was truly a disheartening occurrence.

As we were leaving, I turned around to take a photo of the site and thought that I glimpsed someone standing in the tree line watching us, but upon examination of the photo later on, it showed no one there. Perhaps it was all my imagination, or possibly one of the soldiers was silently acknowledging what we had done, though no one can know for sure. Either way, one thing

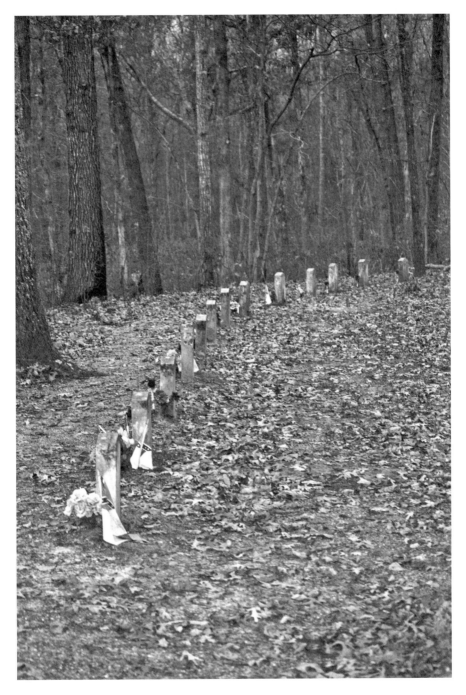

The graves of thirteen unknown Confederate soldiers lie next to a section of the Old Trace a short walk from the Natchez Trace Parkway. *Photo by Bud Steed.*

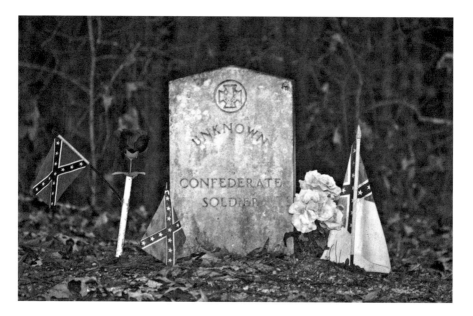

Grave of an unknown Confederate soldier. All of the graves were decorated in much the same way with silk flowers and small Confederate flags to signify that while their identities might not be known, their sacrifice would not be forgotten. *Photo by Bud Steed.*

is for certain: the place has a feeling of deep sadness about it, and one can almost feel himself being immersed in as he enters the grave site area. It's almost as if something much more tragic than the passing of wounded soldiers and their subsequent burial occurred here.

Over the years, people have reported everything from voices moaning as if someone was in pain to the usual balls of light and mists that seem to get reported at nearly every burial site. The smell of wood smoke has been reported as well from time to time, even in the hot summer months, though no source of the smoke can be located.

PART 2

ALABAMA

CHEROKEE AND FLORENCE AREA SITES

The Natchez Trace Parkway enters Alabama at milepost 308 and exits the state at the Tennessee state line at milepost 341, spanning a total of thirty-three miles and crossing over the wide Tennessee River. Four exits allow entrance and egress from the Trace along the Alabama portion. Connections from the Natchez Trace Parkway allow access to the town of Cherokee from exits 320 and 326, and access to Florence, Alabama, a beautiful city less than fifteen miles from the Trace, can be found at exits 333 and 336.

BUZZARD ROOST STAND

At milepost 320.3 on the Trace, we come to the Buzzard Roost Stand site, an inn on the Old Trace that was run by Levi Colbert, a half-breed chief of the Chickasaw and brother to George Colbert, who ran Colbert's Stand, located about five miles north along the Trace. The site was built at a huge spring named Buzzard Sleep, but after Levi built his inn the name was changed. Levi Colbert built his stand in 1801 when the Trace ran through lands that were owned by the Chickasaw. The stands were all owned by Chickasaw tribe members, and Levi was an important chief among his people, having demonstrated much courage and fighting prowess.

When Creek Indians attacked the village that was Levi's home, he organized the men into a fighting unit and led them to victory over their

attackers. He received much honor at council, being seated on a bench rather than on the ground, and received the name "Itawamba Mingo," reported to mean "Bench Chief." He was highly respected not only by his own people, the Chickasaw, but also by the whites and earned the nickname of "Levi the Incorruptible."

Travelers who stayed at Buzzard Roost remarked what a wonderful place it was to stop and said that they were well received, well fed and kindly treated. Apparently, some were treated so well that they have stayed around the area where the stand was once located. Some visitors have heard voices, so loud that they seemed to be standing right next to the witness. People have reported feeling touched, having their clothing tugged on and even feeling what seemed to be spider webs blowing across their faces and arms, even though it was a calm day with no wind.

COLBERT'S STAND AND FERRY

George Colbert, brother to Levi Colbert and an influential chief of the Chickasaw in his own right, opened an inn on the bluffs above the Tennessee River that can be accessed from the Natchez Trace Parkway at milepost 327.3. In addition to his stand, he also operated, in partnership with his brother Levi, a ferryboat with which he ferried people, livestock and goods across the river. He operated his stand and ferry from 1800 to around 1819, offering travelers a hot meal and a place to sleep, along with safe and dry passage across the Tennessee River.

His usual fee was fifty cents per person to cross the river, and if you were lucky enough to be traveling the Trace by horseback, you could expect to pay an additional fifty cents for your mount. He was characterized by a traveling preacher as being "shrewd, talented and wicked," presumably because of his skill at making money. He is credited with once charging General Andrew Jackson $75,000 to ferry his men, mounts and equipment across the river on their return from the War of 1812. Legend has it that he never received payment for the bill he submitted to the government.

Colbert's Stand was a two-story building, with the lower half serving as the place to take your meals and to socialize by the fireplace. The upper half was the living quarters for the Colbert family, and travelers were lodged in an outbuilding named "Wilderness Haven," where they would share the space with whoever happened to be there. Dinner was usually venison, and one traveler who spent the night at Colbert's recalled sharing the outbuilding

The Tennessee River near the site of the ferry operated by George Colbert from 1800 to 1819. He once charged Andrew Jackson $75,000 to ferry his army across the river on their return from the Battle of New Orleans. *Photo by Bud Steed.*

The sign for Colbert's Stand on the Natchez Trace near the Tennessee River in Alabama. *Photo by Bud Steed.*

with "not less than fifty Indians, many of them drunk." Nothing remains of the stand or outbuildings today, with the exception of a well casing and a small paved walkway.

George was as dedicated to the Chickasaw people as his brother Levi, and for more than thirty years he would negotiate with the government for fair treatment and equal rights of the Chickasaw Nation.

Paranormal occurrences that happen at both the stand site and the ferry site are said to include voices of men talking as if in conversation and visitors being poked, having their clothing tugged and their hair touched. The specter of a man is seen sometimes standing on the bluff behind where the stand used to sit, seemingly just standing there staring out over the water. When approached or hailed he is said the turn around, raise his hand as if in acknowledgment and then fade quickly from sight. Native American apparitions have been seen moving in the woods near the stand site, as well as along the bluffs above the river.

Stories of canoes piloted by Native Americans and frontiersmen have been reported on the river also. One was seen shoving off from shore near the ferry site, moving out about fifty yards into the river and then slowly disappearing from sight in what was described as a thick mist that formed

The site where Colbert's Stand once stood. Nothing remains today but a well casing and a portion of a sidewalk. While the building is long gone, it's said that some of the residents and visitors still remain. *Photo by Bud Steed.*

quickly and then faded away. While visiting the site in November 2011, both my wife, Jennifer, and I experienced unexplained poking and having our hair touched. It was not an unpleasant experience, likened more to the poking or tugging of a child who is trying to get your attention. The touching of my hair happened at the water's edge and felt exactly like someone running her fingers through my hair. It happened several times and was done very gently, almost in a loving fashion. Neither of us could find an explanation for our experiences and simply chalked it up to the curiousness of the spirits of Colbert's Stand.

Florence

Access to Florence can be had from the Trace by Highways 14 and 20, and the thriving city sits less than fifteen miles from the exits. It was established on March 12, 1818, from land owned by the Cypress Land Company and laid out by Italian engineer Ferdinand Sannoner, who named it after his favorite city in Italy. The first public land sale was held in July 1818, with a second being held in 1823. Public records show that 180 people acquired city lots from the two sales, including Andrew Jackson. The town was officially incorporated in 1826, although almost from its inception it had served as the county seat.

The town grew and prospered, becoming one of the first textile centers in the Southeast with many fine homes being built, several of them still standing today. It prospered in part due to its access to the Tennessee River, its proximity to the Natchez Trace and in part from the Jackson Military Road that was constructed from 1817 through 1822 and ran through Florence. The military road built by Andrew Jackson with military labor and government funding effectively cut nearly two hundred miles off the route from Nashville to New Orleans. In 1819, the official mail route was transferred from the Natchez Trace to pass through Florence by the military road.

In the winter of 1834, the infamous land pirate John Murrel was captured near Florence on Waterloo Road. Murrel was said to have killed over four hundred people, many of them slaves, during his years of murder and thievery up and down the Trace. He went on to serve his prison time in Tennessee and died shortly upon his release.

The Civil War saw a lot of action around Florence, with the town changing hands several times and nearly all of its industry and some parts

of the town destroyed. Skirmishes in the streets of Florence in 1862, two in 1863 and four in 1864 produced quite a few casualties, leading to local buildings, such as the Pope Tavern, said to have been built in 1811, being pressed into service as hospitals, treating wounded Union and Confederate soldiers alike. Injured soldiers were brought to Florence from other battles and skirmishes in the area to be treated and nursed back to health or to end up being buried in the Soldiers' Rest section of the Florence Cemetery, established in 1818. Many unknown soldiers, both Union and Confederate, went to their final rest in that section of the cemetery. An old Confederate fort was located in Florence near where the coliseum now stands. It consisted of earthworks constructed by Confederate general Daniel Ruggles to protect Florence from Union attack from the river. It has been said that at the time of its construction in 1862, there were over five hundred sick and wounded soldiers being cared for in Florence, casualties of the Battles of Donelson and Fort Henry. It was shelled in 1864 by two Union gunboats that were trying to prevent the river crossing of Confederate General Hood's army after their defeat in the Battles of Franklin and Nashville. The Confederate troops barely made it across, with General Nathan Bedford Forrest's men being the last to cross.

In the winter of 1865–66, an outbreak of smallpox hit the city of Florence, resulting in many deaths. A pesthouse, which was basically a hastily thrown together structure designed to quarantine the sick, was built away from the town, and all of the sick were taken there to either recuperate or die. A cemetery was located nearby where the unfortunates were quickly buried, most in unmarked graves. Still, the city of Florence recovered and continued in its rebuilding after the war came to a close.

On September 4, 1872, a lynching took place that was without a doubt justified. "Mountain" Tom Clark, leader of several notorious gangs who robbed, murdered and terrorized the area during the war and in the years afterward, was captured and locked up in the city jail. Clark, who had often boasted that no one would run over him, was a remorseless killer who admitted to the murders of nineteen people, including a child. The citizens, incensed over his crimes, removed him and two of his compatriots from the jail and promptly lynched them. Graves were being dug in a field when someone remembered his boast about no one running over him. The members of the lynching party dug a grave in the middle of Tennessee Street so everyone who passed down the street would "run over" Mountain Tom Clark, bringing his boast to naught. His body is still said to be buried under the street.

Progress was made in growing and rebuilding the town, and from the year 1887 through 1890, the population jumped from 1,600 people to around 6,000. The establishment of the Florence Wagon Works in 1889 undoubtedly contributed to the rise in population as it was the largest wagon factory in the South and was said to be the second largest in the nation, employing just over 175 people and manufacturing fifteen thousand wagons each year. Florence has continued to grow and thrive as a shipping and distribution point on the Tennessee River, as well as being centrally located in what has been termed the "Growth Triangle," the area formed between Memphis, Nashville and Birmingham. It is one of the fastest-growing areas in the country, with the Florence–Muscle Shoals area alone containing approximately 270 manufacturing and distribution operations. Florence is both an economic and cultural center, and it has retained much of its rich heritage, with many Victorian and antebellum homes being restored to their original appearance. Florence also has a rich history of ghosts and hauntings, with Florence native and author Debra Glass hosting ghost walk tours through some of the most well-known spots.

The cemetery located near the pesthouse, as well as the grounds where the house was located, has been said to be haunted, and unexplained voices, moaning and balls of light darting about have all been reported. The Florence Cemetery, established in 1818 and containing the Soldiers' Rest Military Cemetery, has been reported to be occupied by the ghostly figure of a lady in white. Said to suddenly appear among the tombstones on the darkest of nights, she glides a short distance to slowly fade from sight. No one knows who she is or why she remains, and since the cemetery was the principal place of burial for over 130 years, the possibilities of who she might be are many. Specters of Civil War soldiers have been seen both in and near the Soldiers' Rest portion of the cemetery, voices and shouts have been heard and streaks and balls of light and also mists that form and then suddenly dissipate have all been seen.

The Sannoner Historic District 1, located just north of Hermitage Drive on Court Street, holds several fine antebellum homes built between the 1820s and 1850s. They were the homes of wealthy planters, merchants and lawyers, with the district containing twenty-five historic structures on North Court and North Pine Streets. One home named Wakefield is reported to have a ghostly occupant who enjoys moving things about the house. Glasses are switched around in the cupboards, moved from one table to the next, and keys mysteriously disappear only to reappear in unlikely spots several rooms away. The apparition of a ghostly couple is seen strolling down Court

Street, arm in arm, seemingly lost in each other's company, and the sightings of Civil War soldiers have been reported in numerous places throughout the historic districts.

The Pope's Tavern building, reported to be one of the oldest buildings in Florence and one of several structures pressed into service as a hospital during the Civil War, is reported to be the site of some paranormal occurrences. Moaning has been reported in the building late at night, as has unexplained knocking and banging. People have reported being touched and having their hair pulled and stroked. Items on display have been moved about, and chairs have been found moved when the building is opened up in the morning.

Sweetwater, once the home of Major John Brahan, a veteran of the War of 1812, who owned approximately four thousand acres, is said to be haunted as well. The home was also occupied by both the Confederate and Union forces and was also the home of Governor Robert M. Patton, John Brahan's son-in-law. Faucets are said to turn on and off by themselves, as do the second-floor lights. Music has been heard coming from an old piano that sat in the parlor of the home, a place where the governor often entertained guests.

There are many more tales of hauntings and ghostly happenings associated with Florence and the surrounding areas, mostly due in part to the rich history of the city. One need only take an evening stroll through the historic districts to experience the history and stories of the town and perhaps even a ghost or two if you are lucky.

PART 3

TENNESSEE

ALABAMA STATE LINE
TO THE NORTHERN TERMINUS
NEAR NASHVILLE

The Natchez Trace begins in Tennessee at milepost 341 and ends at milepost 444 at the northern terminus near Nashville. The terrain is moderately hilly and has some sweeping twists and turns, as well as a few tighter ones that force the speed limit down from the usual fifty miles per hour to forty. Several cities are accessible from the Trace, including the nice little town of Collinwood that has a wonderful welcome center and the town of Hohenwald, the location of the Elephant Sanctuary, the biggest natural habitat sanctuary for elephants in the United States. The city of Franklin is located about ten miles east of the Natchez Trace Parkway and is accessed from Highway 46, located at milepost 428. Franklin is the site of the Battle of Franklin, a major Civil War battle that was fought on November 30, 1864. The action resulted in casualties of nearly ten thousand soldiers who included killed, wounded, captured and missing men and turned forty-four buildings into temporary field hospitals. There is much to see and do along this section of the Trace, including some very beautiful scenery.

Highwaymen were very active along this section of the Trace, taking advantage of the weariness of travelers who might for a moment let their guards down, giving the brigands an opportunity to murder and rob them. Such is the tale of famed explorer Meriwether Lewis, one-half of the leadership of the Lewis and Clark Expedition, who met his death along the Trace one night under mysterious circumstances.

Grinder's Stand and the Death of Meriwether Lewis

Grinder's Stand was a log cabin inn set along the Old Trace near present-day Hohenwald, Tennessee, and is believed to have been established around 1807. It was a structure typical of the times, with two small log rooms connected by a "dogtrot" or breezeway. It supposedly had a door facing the Trace in each of the log rooms and a door in one section that faced the rear, allowing access to a detached kitchen area immediately behind the stand. The stand also included a barn and stable located behind the home.

The proprietors of the stand were Robert and Priscilla Grinder (spelled Griner in some records), and they eked out a meager living from the stand, providing food and lodging to travelers moving along the Trace. By some accounts, they supplemented their income by selling whiskey and "high wine" to the Indians whose lands bordered on theirs, an illegal act in those days. They were not considered well off or even financially comfortable by any means, and some historians have questioned their ethics and morals, pointing to their association with a known local land pirate, named Tom Runions, who later married one of their nieces,

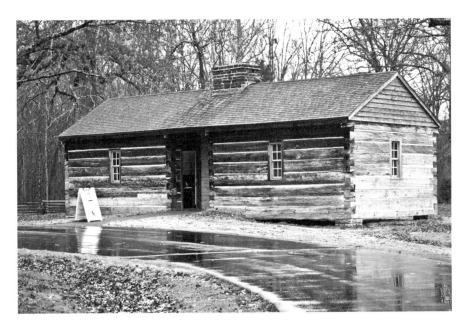

Cabin at Grinder's Stand that now houses a National Park Service information and gift center. It is a reproduction of the cabin that was operated by the Grinders; the original site is less than twenty yards from this cabin. *Photo by Bud Steed.*

a Perthania Grinder. Runions was considered by all accounts to be a dangerous man who would show no mercy to anyone who attempted to expose his murders and thievery.

On September 4, 1809, famed explorer and then-governor of the Upper Louisiana Territory Meriwether Lewis left St. Louis accompanied by his free servant, John Pernier, on a boat bound for New Orleans. He supposedly intended to board a ship out of New Orleans and sail to Washington, D.C., to straighten out some financial matters and receive reimbursement for expenditures related to his office that he had paid with his own funds. His clothing, papers and other items were packed into four trunks, and both men, with their belongings secured on the boat, set off. Lewis, from entries in his own diary, became ill, and by the time they reached Fort Pickering at Chickasaw Bluffs, the site of present-day Memphis, he was extremely weak and in poor condition. The fort's commander, Captain Gilbert Russell, decided that he should detain Lewis for his own good until such time as he could recover sufficiently to continue his travels. The next day, Lewis wrote a letter to President James Madison letting him know that he had reached Fort Pickering safely and apprising him of his physical condition. It was then that he changed his mind about continuing on to New Orleans, stating that his fear of his original papers falling into British hands had induced him to travel overland to Washington, D.C.

While there is no doubt that rumors of war with the British were being talked about, that might not have been his only reason for suddenly changing his course of action. Three years before, Aaron Burr and General James Wilkinson had plotted with the Spanish to form a separate nation from the Mississippi Valley out to the Southwest, and it was only by betraying Burr that Wilkinson was able to conceal his part in the treasonable act. Wilkinson at that time was holding down the position that Lewis now held and had been removed from that position and put in charge of the U.S. troops in New Orleans. Wilkinson had supposedly accepted payments from the Spanish while he was governor of the Upper Louisiana Territory. While merely speculation, some believe that Lewis had uncovered this and that it was also part of his agenda for his trip to Washington. His secret reasoning behind his change of plans could be that he might have feared confrontation with Wilkinson in New Orleans and thought himself to be safely out of Wilkinson's reach traveling through Tennessee.

This is where the story starts to take a few twists and turns. According to the record, Lewis was joined by Major James Neely, the Chickasaw Indian agent who, with his servant and a number of Chickasaw Indians, set out

across Tennessee. According to Neelly in a letter that he wrote to Thomas Jefferson about the death of Lewis, he stated that they rested for ten days at the Chickasaw Nation, during which time he became convinced that Lewis was acting deranged. A similar letter that supposedly came from Captain Russell detailing the deranged behavior of Lewis was also sent to Jefferson. Interestingly, modern-day forensic handwriting analysis confirmed this letter to be a forgery and not written by Russell at all. After their rest period, they set out along the Trace, and one day after crossing the Tennessee River, they lost two of their horses. Oddly enough, Neelly did not bother to keep his servant with him to help recover the horses but rather sent him on with Lewis and Pernier, promising to meet them at the first house they came to that was occupied by white people. The Lewis party continued on until they reached Grinder's Stand, and by all accounts, Robert Grinder was not at home, but his wife, Priscilla, gave the group food and lodging.

Lewis was given the extra room, and the servants were lodged in the barn, with Mrs. Grinder occupying the remaining room. Just slightly after midnight on October 10, 1809, according to Mrs. Grinder, she heard a shot come from the room, and Lewis screamed, "Oh Lord!" followed by a second shot. Her story changed at least three times from that point, with one version stating that she remained in her room for the rest of the night, too afraid to leave even though she heard Lewis call to her asking for water. Another time, she stated that she entered the room and found him shot twice and that he lived through the night, but when she went to check on him the next morning, she found him in the process of cutting himself from head to toe with a razor. He reportedly died a few hours later. Her third version of the story came several years later, when she stated that Lewis had confronted three men in the yard of the stand and had pulled two pistols, ordering them to leave. She also added a third pistol shot to his death and related that Pernier had shown up the next morning wearing the same outfit that Lewis had arrived in. When questioned about it, he merely stated that Lewis had given it to him. They supposedly searched for Lewis and found him a distance away on the Trace, still alive though badly wounded. They brought him back to the cabin, where he died a short time later.

Additionally, moccasin tracks and the imprint of an unusual rifle butt were found all around the cabin the next morning. The markings on the rifle butt were recognized as belonging to the aforementioned land pirate Tom Runions. Just what he was doing there and whether he had anything

to do with the death of Lewis was never pursued, although it did generate a few hushed speculations. There are simply too many stories filled with too many discrepancies about what happened that night.

Also contained in the letter that Neelly wrote to Jefferson was his account of coming up to Grinder's shortly after Lewis had died and of burying Lewis that afternoon. This was recently proved to be false by researchers who discovered Neelly's name and signature on court documents at Franklin, Tennessee, a full day's ride from Grinder's Stand, dated the exact day of Lewis's death. Neelly, who also had no money when they left the Chickasaw agency, supposedly gave Pernier $15 to travel on to Washington and make a report to Jefferson. No mention was made of the $120 that Lewis had on his person when he left, nor was it ever forwarded to his relatives. Pernier, who traveled on to Washington to make his report, was found dead shortly after his arrival. Some say his throat was cut, while others said that he either took or was force-fed a lethal dose of laudanum.

Oddly enough, the death of Meriwether Lewis was ruled a suicide, mainly based on the accounts of Neelly, Pernier and Mrs. Grinder, all of whose motives were suspect. He supposedly shot himself twice with two .69-caliber flintlock pistols, once in the head and another in the chest. His final words were reported to be: "So hard to die."

Sometime around 1810, though the records are a bit unclear, the once fairly destitute Grinders up and moved from their stand to western Tennessee with enough money to purchase land and slaves with which to work it. The pocket watch of Meriwether Lewis also turned up in a pawnshop in New Orleans several years later, although no record of how it got there was ever discovered.

Lewis was buried near Grinder's Stand in a grave marked by a bit of fencing. In 1848, the State of Tennessee erected a monument over the spot of his burial, a broken column symbolic of his early and untimely death at a young thirty-five years of age. His grave is part of the Pioneer Cemetery, although the original headstones were removed from the graves and replaced with flat markers, making it easier to mow around the monument. The flat markers were not placed back over each grave either but were arranged in concentric circles around the monument to Lewis. Apparently, this made a few of the residents of the cemetery a bit disgruntled.

Reports of people being touched, poked and pushed while visiting the cemetery have been described quite frequently. Voices have been heard in the evening hours, as well as in the early morning. One such voice was

The monument to Meriwether Lewis, located in the Pioneer Cemetery next to Grinder's Stand where Lewis met his death by suicide, though some claim he was murdered. *Photo by Bud Steed.*

quoted as saying, "They have defiled us," which I can only take to mean the gravestones. The supposed voice of Meriwether Lewis has been reported also, saying, "So hard to die," thought to be his last words. At the site where the Grinder cabin stood, a short twenty yards or less from where the reproduction cabin now stands, the ghost of Lewis is reported to whisper those same words along with the repeated word "Why?" as if asking why he died or perhaps why he was murdered. Figures have been seen moving in the trees near the new cabin, and mysterious lights and, oddly enough, the sound of a bell, like the kind one might ring to summon a servant, have been heard on several occasions.

All in all, when the sky starts to darken around the area of Grinder's Stand, when the silence of the night wraps itself around everything and everyone in sight, the area does take on an eerie feel. It's almost as if you can feel the ghosts close in around you and unseen hands reaching out as if trying to get your attention. One can't help but come to the conclusion that someone wants to tell you something, and it just may be Lewis himself.

GORDON HOUSE HISTORIC SITE

Located at milepost 407.7 is the entrance to the parking area and sidewalk that leads to one of the few remaining buildings associated with the Old Trace. Around 1801 or 1802, Captain John Gordon, a distinguished soldier and Indian fighter, made an agreement with the Chickasaw chief George Colbert to operate a stand and ferry crossing on the Duck River site of the Natchez Trace. By all accounts, he built a small cabin and started operations, but by 1805, the Indians had been pushed off that particular stretch of their land, and Gordon was awarded 640 acres on the Duck River as payment for his military service.

Sometime between 1808 and 1812 (the exact date isn't really clear), Gordon moved his family from Nashville down to the Duck River. His family operated the stand and ferry crossing during his absence while he was off fighting in the Creek Indian Campaign of 1813–14. His wife, Dorothea, or "Dolly," as she was also known, initiated the start of the construction of the brick home that currently stands on the site around 1817. John would again join the military and fight during the Seminole Indian Campaign, giving detailed instructions before he left and providing additional directions for the building of the home by letters sent to his wife. She oversaw the construction of the home, which was finished around 1818 and was one of the first brick

The Historic Gordon House on the Natchez Trace. The Gordons operated a stand and ferry crossing on the Duck River, the ferry crossing just a short walk past the house. *Photo by Bud Steed.*

structures within a thirty-mile radius of the Natchez Trace that was used as a private dwelling. John would return from fighting the Seminole in 1818, and he lived in his new home for just under a year before he succumbed to pneumonia, leaving behind his wife and a rather large family.

Dorothea, obviously a strong woman to have operated the ferry and the farm and raised her children while John was away fighting Indians, fell to the task of keeping everything running, operating the enterprise until her death in 1859. She died in the home that she had supervised being built and was buried next to her husband in Columbia, Tennessee's historic Rose Hill Cemetery. The ferry would operate for over ninety years until a bridge crossing the Duck River was erected in 1896.

On their return home from the War of 1812, Jackson's troops stopped here to rest before pushing on to Nashville. Stories have been told that some of the sick soldiers passed away and were buried behind the house, back by the tree line near where they were camped. The graves were unmarked, lost forever to time. The Civil War saw troops, both Union and Confederate, use the ferry crossing in their travels. The ferry played an integral part in that section of the Trace, as did the Gordon House, for many years.

Visitors to the Gordon House and to the site where the ferry once operated have reported hearing voices coming from the house even though it is securely locked. A woman has been seen in the second-floor window, gazing out toward the field. She has been described as being around thirty years of age with dark hair, wearing a dress with a high collar. Those who have seen her thought that she might be part of a period reenactment or something, only to discover that no reenactments were being held, the building securely locked from the outside. The muted sounds of conversation have been reported down where the ferry crossing used to be, as well as reports of hair being touched and gently pulled. The figure of a man has been seen standing above the water, going through the motions of what would most likely have been moving the ferry across the river. He is seen momentarily, intent upon his work, only to vanish midway across the water. No boat is seen, just the man moving about two feet above the water.

Old Trace near Garrison Creek

A section of the Old Trace is located at milepost 426.3 very near Garrison Creek. An army post was located near here in 1801–02 while the Natchez Trace was being improved from Nashville heading south into the Chickasaw lands. The soldiers worked hard at clearing and widening the Trace, making it more suitable for wagons and coaches to travel. They provided additional security for travelers, helping to alleviate some of the anxiety from the constant threat of robbery and murder.

This section of the Old Trace has the usual reports of voices, touching, poking and hair pulling associated with many haunted spots both along the Trace and in other locations, but it also has a very different type of occurrence associated with it. People walking along this section have reported hearing the sounds of an axe striking a tree, that wooden *thunk* associated with the bite of an axe, and they have remarked on the steady rhythm, as if two people were working on felling the same tree. They have also told of hearing the sounds of trees falling, seemingly as if they were hitting the ground right next to them. Perhaps this is a residual sound left over from when the Trace was being widened, but regardless of the source, it is an unusual type of spectral sound and not your normal type of haunting.

A section of the Old Trace near Garrison Creek in Tennessee. When the travelers hit this section of the Trace, they knew their journey was almost at an end. *Photo by Bud Steed.*

LEIPER'S FORK

At milepost 428 on the Trace, you will come to the exit for Leiper's Fork, a small, unincorporated village located on Tennessee Highway 46. The town is located one mile from the Natchez Trace Parkway, though the Old Trace ran right through the center of town.

The village sits on part of the 2,504-acre land grant that was awarded to Colonel Jesse Steed around 1790 for his military service. The land was later purchased by Jesse Benton around 1801. Jesse Benton was the father of Thomas Hart Benton, who later became a U.S. senator from Missouri. By 1818, a post office had been established in the village, mainly because of its location on the Trace, and the little community grew and prospered, with the name eventually changing from Hillsboro to Leiper's Fork after a family who had settled there along the creek.

The village today is listed as a National Historic District and sports a few Victorian-style homes, several businesses and a whole lot of friendly residents, both living and departed. Several of the privately owned homes in Leiper's Fork are reputed to be haunted. One home is shared with the spirit of a young girl who seems to enjoy moving things around and has been seen

Coming into Leiper's Fork on State Route 46, you pass the historical sign and this old police car, reminiscent of the one used in *The Andy Griffith Show*. The license plate even reads "Fife," as in Barney Fife, the character played by Don Knotts on the show. *Photo by Bud Steed.*

View of the main street of Leiper's Fork, Tennessee. *Photo by Bud Steed.*

running up the stairs only to disappear at the top. Footsteps are heard as if someone is moving around upstairs, even though no one is up there. The sound of a ball bouncing down the stairs has also been heard, though no ball is ever seen.

The dark, shadowy figure of a man has been glimpsed down near the creek on the north end of town. He seems to be standing there with his head

bowed as if watching the water flow by, only to disappear without moving. Shadow figures have been seen around the buildings at night, as well as along the road that leads from Highway 46 to the school.

FRANKLIN AND THE BATTLE OF FRANKLIN

Approximately eight miles east of the Natchez Trace on Highway 96 and twenty miles south of Nashville sits the city of Franklin. Established on October 26, 1799, by Abram Maury Jr., it is the county seat of Williamson County and is named in honor of Benjamin Franklin. The first house was built by Ewen Cameron, a Scotch immigrant who lived in the log structure for forty-eight years before passing away in 1846. He is buried in the old city cemetery with his second wife, Mary, and his descendants have lived in Franklin continuously since his son, Duncan, was born in 1798.

From the time of its inception to the years just prior to the Civil War, Williamson County was one of the wealthiest counties in Tennessee, and Franklin was the hub of the plantation economy. The Civil War struck, however, and like most towns, the local economy was devastated. The city was occupied by Union forces for nearly three years, and the second Battle of Franklin, fought on November 30, 1864, was considered to be one of the bloodiest battles of the war. Nearly ten thousand soldiers were reported killed, wounded, captured or missing in the aftermath of the battle, with nearly every remaining building in the city being pressed into service as a hospital, treating both Union and Confederate soldiers alike.

It would take nearly 120 years for the economy to reach its pre–Civil War level, but today Franklin is one of the wealthiest cities in the country and home to a long list of famous performers such as Brad Paisley and Lee Greenwood. Franklin has recovered exceptionally well and seems to have a bright future ahead of it as a safe, thriving economic community just a short drive from Nashville. Besides being home to a few famous residents, it is also home to more than a few ghosts, the majority seeming to come from the Battle of Franklin.

The Battle of Franklin stemmed from Confederate general John Bell Hood's desire to smash the Union forces in Tennessee and capture Franklin and Nashville. He then planned to rally additional troops to drive through Tennessee, Kentucky and on to meet up with General Robert E. Lee's army in Virginia, effectively crushing the Union opposition and turning the tide of the war in Confederate favor. It was a grandiose plan and might have

worked had things turned a bit more in his favor, but in war, the same as in life, things don't always go the way we plan them.

The Union army under the command of General Schofield learned of the impending attack and had enough time to fortify its positions, with Schofield deciding to defend at Franklin while giving his supply trains enough time to evacuate to Nashville. His decision to fight at Franklin proved to be the right call, as his supply trains safely made it to Nashville, and the way remained open for the withdrawal of his army once the fighting was over.

The Union army had a series of entrenchments set up all along the line. The attacking Confederates would be forced to cross an open field, said to be close to two miles wide, in full view of the Union forces and their weapons. Once across, they would face a ditch four feet wide and two to three feet deep, with a wall of earth and wooden fence rails four feet high as their next hurdle, only to meet the Union defenders who were standing in a trench three to four feet deep, firing their weapons through gaps in the fortifications called "head gaps."

The fighting was especially fierce all along the lines, at times hand-to-hand with bayonets, entrenching tools, axes and anything else that could be employed as a weapon. The fighting abated that night, and the Union army withdrew, making it safely to Nashville, where it would yet again face the army of General Hood.

Casualties were estimated to be 189 killed, 1,033 wounded and 1,104 missing for the Union force. The Confederate forces fared much worse, with a reported 6,252 casualties, of which 1,750 were killed. In addition, the Confederates lost fourteen generals, among them Patrick Cleburne, who was considered possibly the best division commander of either side. Six Confederate generals were killed, seven were wounded and one was captured, along with fifty-five regimental commanders being listed as casualties. A costly victory for the Confederate forces, but they held Franklin.

The Battle of Franklin is a terrific, if gory, story of the heroic sacrifices of soldiers from both sides, and my abbreviated telling of it here cannot do the battle justice. I would recommend that anyone with even a passing interest in the Civil War read a little deeper into the battle.

The city of Franklin is reported to be an extremely haunted area, and with the huge loss of life and the fear and horror of the battle being experienced firsthand by so many, it is little wonder. Apparitions have been seen all over downtown Franklin, the ghosts of Civil War soldiers appearing and then disappearing, sometimes speaking before they fade away. Several sites seem

to have more than their fair share of unearthly occupants, one such site being the Carnton Mansion.

Located at 1345 Carnton Lane, the mansion is now a museum run by the Carnton Society, but during the battle, it was the site of some of the bloodiest fighting. The grounds also hold the remains of approximately 1,700 Confederate soldiers who were killed in the fields near the home and were quickly buried. The home itself was utilized as a hospital after the battle, and four generals died there of their wounds. They say that during the autumn months the spirits are most active, perhaps because the battle was fought in November. The sounds of heavy boots pacing back and forth on the front porch are heard quite often, and the spirit of a soldier apparently occupies one of the bedrooms. Whether he passed away in the room from his wounds or just decided that he liked it is unknown, but he is obviously content there, letting the owners know he is there by taking a large photo down from the wall and laying it on top of a floor heater. The ghost of a lady dressed in white haunts the back porch, sometimes floating off into the yard before disappearing. The ghost of a cook who used to work for the family has been seen in the kitchen area, and she is often heard moving around, apparently still attending to her duties. A young girl, a house servant, was murdered in the kitchen by a field hand in the 1840s, killed for rejecting his advances. Her spirit is said to haunt the kitchen and the enclosed back porch area and is quite fond of playing tricks. She also reportedly still helps out with the chores, having been credited several times with washing the dishes.

The most famous spirit to haunt Carnton is that of Confederate general Pat Cleburne. He is said to pace the back porch and to walk the perimeter of the mansion as if in frustration. He is also reported to speak and interact with lone individuals, at times carrying on a conversation before fading away. The sounds of gunfire, rebel yells and music from a regimental band have been heard at various times, along with the sound of an officer urging his men to charge.

The Carter House, located at 1140 Columbia Avenue, is another home that saw plenty of death as a result of the battle. Built in 1830 by Fountain Branch Carter, it would end up at the center of some of the really bloody fighting. The Union army had commandeered the Carter House as a command post for General Cox, the family rousted out of their beds to watch as the Union troops moved in and started to set up positions. During the battle, the Carters took refuge in the basement, all twenty-two of them, including servants, and for the most part, they were unable to see the fighting taking place all around them, although they had no problem hearing the

shots and the screaming of men as they died. Fighting took place all around their home, with soldiers engaged in hand-to-hand combat on the porches and in the rooms of the house. The Confederates charged the house several times, but each time the Union troops managed to beat them back.

After the battle, the family emerged from the basement and received some bad news. One of the younger sons was attached to the attacking Confederate forces, and after a lengthy search, he was found about one hundred yards from his family home. They carried him back to the house and cared for him for two days before he died. He seems to have never left the home, though; his apparition has been seen by several people, sitting on the bed of the room where he died. The sound of a friendly woman's voice has been heard throughout the house, gaily laughing and carrying on a conversation before fading to silence. The specter of a young girl has been seen on the stairs, and people have reported what felt like a small child tugging at their clothing, as if trying to get their attention. Things have been moved in the home, and during a tour, one guest supposedly interrupted the guide to point out that a statue behind her was moving up and down; the guide and group decided to move on with their tour a little quicker after that.

The house has been opened to the public since 1953, and in 1961 it was listed as a Registered National Historic Landmark. It now serves as a museum dedicated to the Battle of Franklin.

There are many more stories of ghosts and hauntings in the Franklin area. The local cemeteries have all been reported to harbor spirits and balls of light, voices and cries in the night, as well as the usual sighting of a lady in white that seems tied to some ghost story or another in a multitude of different towns. One thing is certain about Franklin Tennessee: there is no shortage of ghost stories or the ghosts to go with them.

CONCLUSION

The original Natchez Trace continued on past Franklin into Nashville, Tennessee, in the old days, marking the end of a long and treacherous journey. One can only imagine the relief that the travelers of the Trace felt when they arrived in town, their money and belongings intact, as well as their lives. So many who traveled the Trace were not fortunate enough to ever see Nashville, having falling victim to robbers, accidents and sickness along the way.

Today, the Natchez Trace is a wonderful road to travel, completely unlike its predecessor, the Old Trace, along which the Kaintuck boatmen and other travelers walked and rode. History permeates the road and the communities that lie close to it, giving credence to the stories and adding to the ghosts and legends associated with it, the murders and robberies of the land pirates and the bloodshed of the Civil War.

Today, we can take our time while traveling the Trace, stopping to experience the history and the legends, learning about the dangers faced by those hearty individuals who once traveled out of necessity where we now drive for pleasure. Looking at the smooth stretch of road, the well-kept grounds that border it and the park-like setting of its parking and camping areas, it's hard to imagine the rough, raw wilderness that once surrounded it. They were a strong courageous bunch that braved the frontier and left their marks on the land. Their spirits were strong, which may be the reason that we have seen so many stories of the paranormal associated with the areas where they once lived, worked and fought. They have truly left a lasting imprint with their passing.

Conclusion

I hope that you have enjoyed this trip up the haunted Natchez Trace. It has been a wonderful experience to write and photograph it and a blessing to share the stories with you. I hope that you will take the time to go and experience the Trace and the communities that sit alongside it.

BIBLIOGRAPHY

BOOKS

Coates, Robert M. *The Outlaw Years.* Gretna, LA: Pelican Publishing Company, 2010.

Crutchfield, James A. *The Natchez Trace: A Pictorial History, Revised and Updated.* Franklin, TN: Territorial Press, 2011.

Daniels, Jonathan. *The Devil's Backbone: The Story of the Natchez Trace.* Gretna, LA: Pelican Publishing Company, 2011.

Gildart, R.C. *Natchez Trace: Two Centuries of Travel.* Helena, MT: American and World Geographic Publishing, 1996.

ONLINE RESOURCES

About.com. "American History." http://www.americanhistory.about.com/od/civilwarbattles/p/cwbattle_tupel.htm.

Explore Southern History. "Battle of Tupelo." http://www.exploresouthernhistory.com/natcheztupelobattle.html.

Mississippi Genealogy Web Project. "Canton, Madison County." http://msgw.org/madison/canton/index.htm.

Mississippi Genealogy Web Project. "Mount Locust." http://jeffersoncountyms.org/locust.htm.

Mississippi Genealogy Web Project. "Rocky Springs." http://claibornecountyms.org/rocky-springs.htm.

Mississippi Genealogy Web Project. "Rodney." http://jeffersoncountyms.org/scrapbookRodney.htm.

Natchez Trace Travel. "Natchez Trace Parkway." http://natcheztracetravel.com/natchez-trace-mississippi.html.

National Park Service. "Natchez Trace Parkway." http://www.nps.gov/natr/index.htm.

Tennessee Genealogy Web Project. "Pioneer Cemetery at Meriwether Lewis Monument." http://www.tngenweb.org/lewis/pioneer_cemetery.htm.

Wikipedia. "Chapel of the Cross." http://en.wikipedia.org/wiki/Chapel_of_the_Cross_%28Mannsdale,_Mississippi%29.

Wikipedia. "Natchez Trace Parkway." http://en.wikipedia.org/wiki/Natchez_Trace_Parkway.

About the Author

Born in Lima, Ohio, Bud Steed is the investigation manager for TOPS, The Ozarks Paranormal Society, based in southwest Missouri. A writer and accomplished photographer, Bud writes weekly columns for examiner. com covering the topics of photography and ghosts and ghost hunting. A lifelong interest in both the paranormal and history have led him to participate in several notable paranormal investigations, the most notable of these being the investigation at Wilson's Creek National Battlefield, where TOPS was the first team to receive a permit from the National Park Service to conduct an overnight investigation of both the battlefield and the historic Ray House. The investigation was filmed by the Travel Channel for its series *Legends of the Ozarks* and produced startling evidence of hauntings at Wilson's Creek.

A firm believer in giving back to his community, Bud enjoys speaking to local elementary school classes about the paranormal, writing and the importance of learning and working hard to achieve their goals. A Freemason belonging to Ash Grove Lodge #100, Bud also participated in the Missouri Child Identification Program (MOCHIP), a free program where parents can receive a computer disk containing all of their child's vital information, including electronic fingerprints and DNA. These disks work in conjunction with any police computer system to aid in Amber Alerts or identification should the child become missing.

Bud has spent much of his time traveling, including living in Germany and France, as well as touring most of Europe while in the army. He has also lived in nine different states since leaving his home in Ohio in 1979. Bud currently lives near Springfield, Missouri, with his wife, Jennifer, and their four children, David, Sean, Ciara Jo and Kerra.

Visit us at
www.historypress.net